Published by
Cazu Productions and Publishing
mail@alcazu.com

Copyright © Alan Williamson

All rights reserved. No part of this publication may be produced, stored in a retrieval system, or transmitted, in any form or by any means, electronic, mechanical, photocopying, recording or otherwise, without the prior permission of the copyright holder.

ISBN 978-1543155761

Book Dedication:
I dedicate this book to my dear uncle Kenny who died earlier this year at the age of ninety-three. He was the champion in my life who first taught me how to paint and draw. During his life he produced thousands of pictures and continued to work daily on his art until his last days. I sorely miss knowing that he is around and still making pictures. You may notice that my name on the cover of this book puts my surname before the name by which my paintings are commonly known and signed. The reason for this is out of respect for the name Kenny Williamson.

Introduction:
Making the pictures would be straightforward but what did I want them to say to those who might take the time to investigate them? I didn't want them to become a series of tourist type images, or a purely aesthetic collection of seascapes. What I did want was a collection of images that faithfully and truly capture the sights and experiences of river life and sailing along the south-shore of the Cornish Coastline.

Where would I look for a style of producing pictures that would be appropriate for this project? If I go back to what first inspired me to draw and paint, it was when I was a small boy and travelled by steam train to visit the seaside. In those days the train stations displayed many posters that depicted a variety of coastal destinations. These were mostly prints being produced from hand painted pictures that had been created with poster-paint or watercolours and rendered in a somewhat stylised style. This I thought to replicate but in a contemporary style of my own. Another of my childhood fascinations was the illustrations in old books that recorded the early explorations of far parts of the globe. The sketches of plants and wildlife done by those early explorers/artists I wanted to pay tribute to so I have attempted to mimic this within this book.

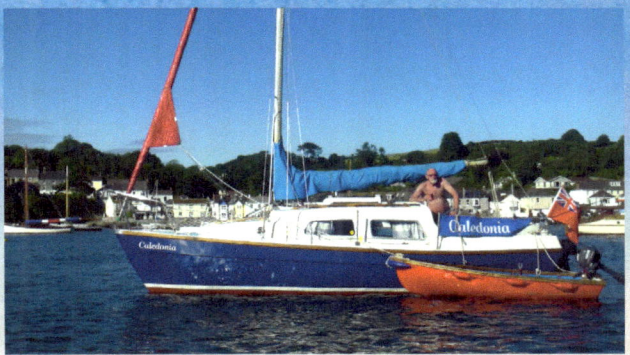

As for viewpoint? I wanted to not make every picture as seen from the same and usual eye-line. So I have made use of photographs that I have taken from my newly acquired underwater camera and flying camera mounted on a quad-copter. This has allowed me to study views from angles and a proximity that would otherwise not be possible.

As for the words that would accompany the images, what would be their purpose and message? I certainly didn't want to write a sailing or fishing narrative, nor did I want to make a travel guide, or an art book. I didn't desire to create an account of what the pictures meaning are to me, or justify why I had created them. So the words that accompany this collection of my sketches are merely extracts from my notebooks and journals. The result has brought about a narrative that is a cocktail of all of the afore-mentioned.

The three rivers that I refer to are located in Cornwall, UK. These being the Helford River, the Penryn River, and the Carrick Roads that leads to the Truro River. The sea that connects these three rivers is the Great North Atlantic Ocean.

In this book I have identified and illustrated the oceanographic chart markings and geographical sightings that mark the entrances to these magnificent rivers and the points where they cease to be navigable. The pages are also interlaced with impressions and images of sailing up and down these rivers and along the coastline that connects them.

Al Cazu

1) Background Image
'Clouds & Flat Seas'
Media: Watercolour
Size: 340 mm * 540 mm

2) Page Right / Top
'Al Aboard The Caledonia'
Media: Photograph
Size: 120mm * 200 mm

Looking Down Through The Clouds At Falmouth Bay

1) Saint Anthony's Lighthouse

2) Saint Mawes

3) Falmouth

4) Carrick Roads

5) Truro

6) Black Rock

7) Penryn

8) Pendennis Castle

9) Easter Rock

10) Helford River

11) Gweek

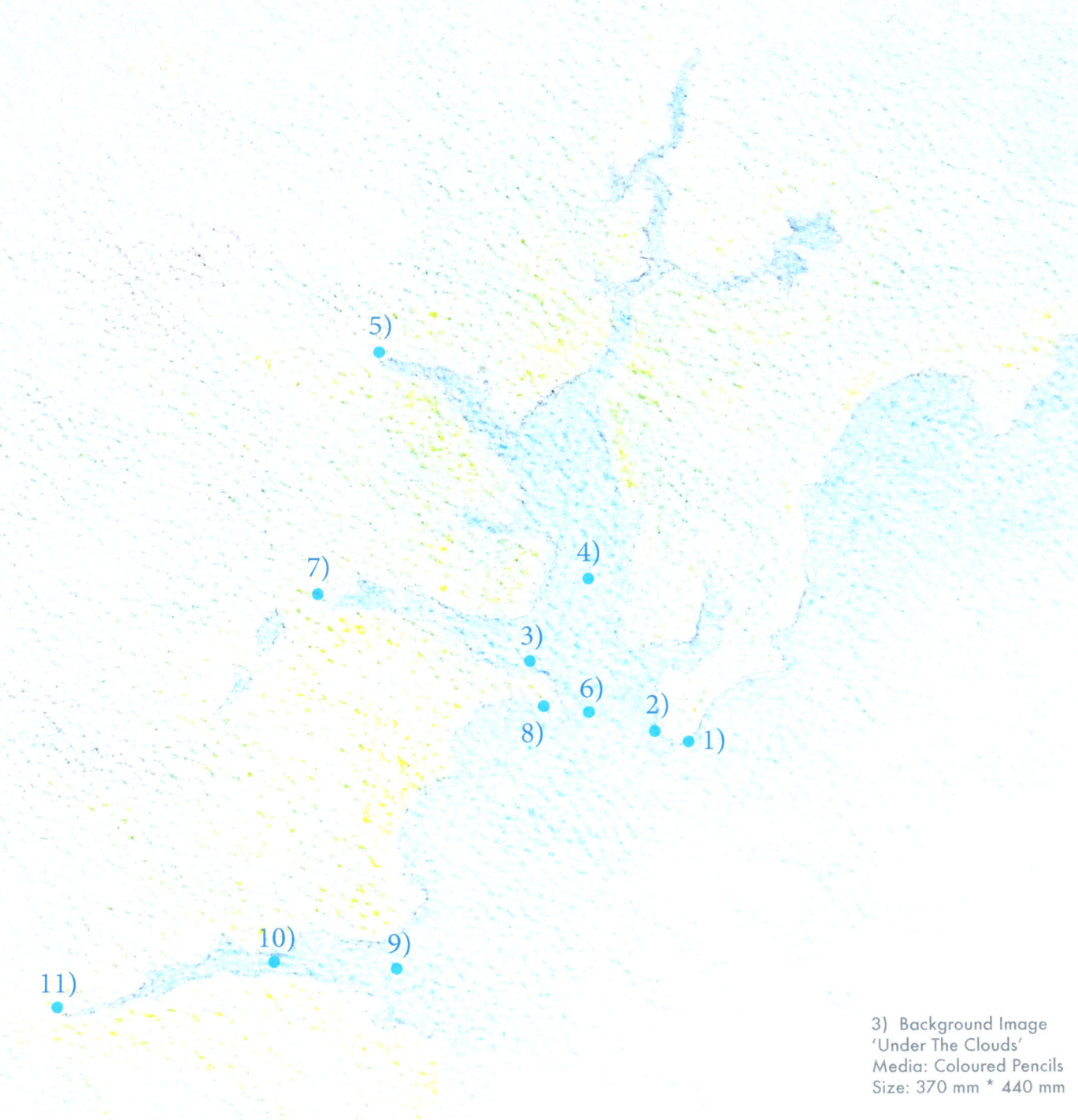

3) Background Image
'Under The Clouds'
Media: Coloured Pencils
Size: 370 mm * 440 mm

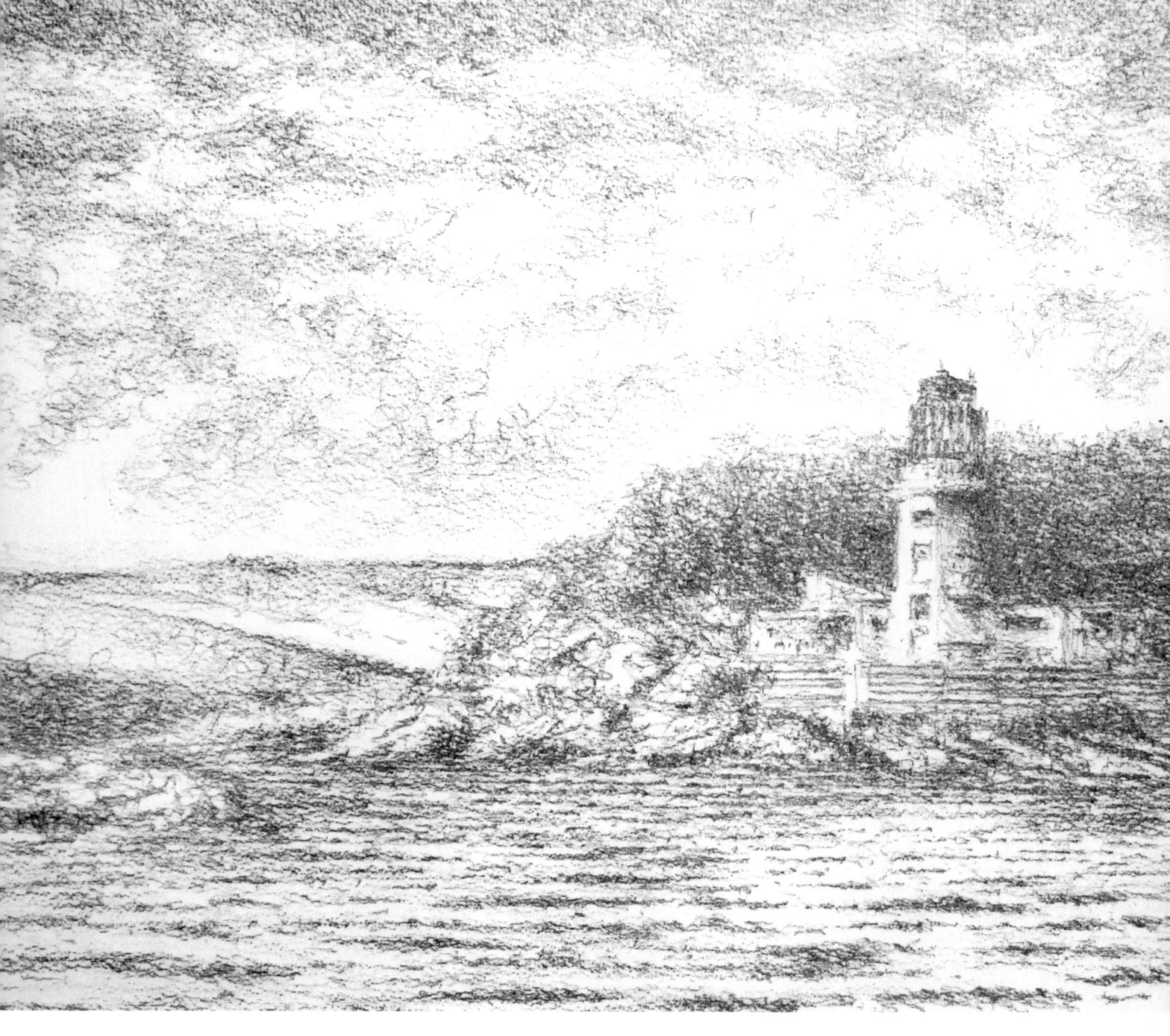

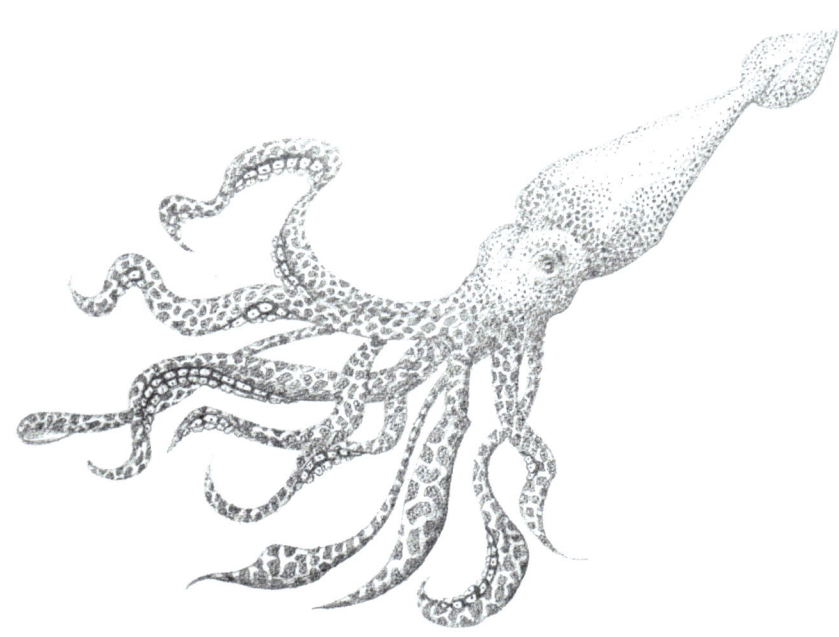

Saint Anthony's Lighthouse marks the beginning of this series of images. This majestic waypoint sits at 50° 8' 28.14" N, 5° 0' 57.84" W Since 1835 This navigational mark has warned oceangoing vessels of the rocky entrance to Falmouth Harbour and the mouth of the Carrick Roads.

In spite of the existance of such a critical navigational aid this coastline is littered with numerous shipwrecks, and is abundant with romantic stories of smuggling. To this day fishing here is extremely fruitful and a wide variety of marine-life exists in abundance. This is a superb location to begin this series of pictures of mine.

4) Page Left
'Saint Anthony's Lighthouse'
Media: Pencil
Size: 540 mm * 340 mm

5) Page Right
'Squid'
Media: Pencil
Size: 370 mm * 440 mm

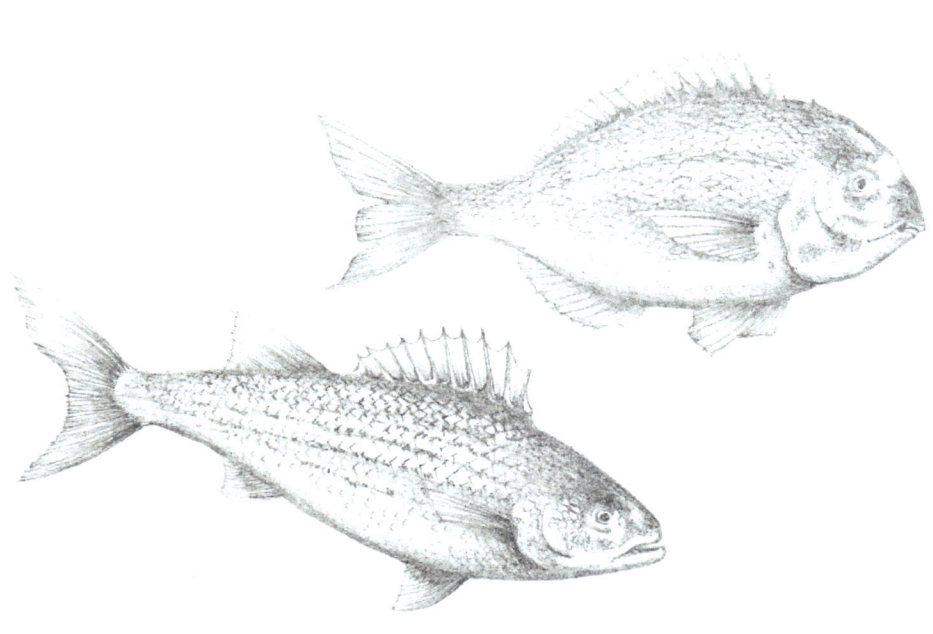

So many skies, and so many seas. The union of these two is inseparable, I have been attempting to interoperate this ever changing scenario and commit my observations to canvas and paper throughout my entire life but I fear that my efforts fall far short of being entirely satisfactory.

Whenever I draw or paint rivers or oceans I can't help but be conscious of what is probably below the surface, hence the pages of this book are interlaced with images of the marine-life that as yet fortunately still inhabit the shores around the area that this book focuses upon.

6) Page Left
'Bream & Bass'
Media: Pencil
Size: 370 mm * 440 mm

7) Page Right
'Waxing Moon At Sea'
Media: Watercolour
Size: 340 mm * 540 mm

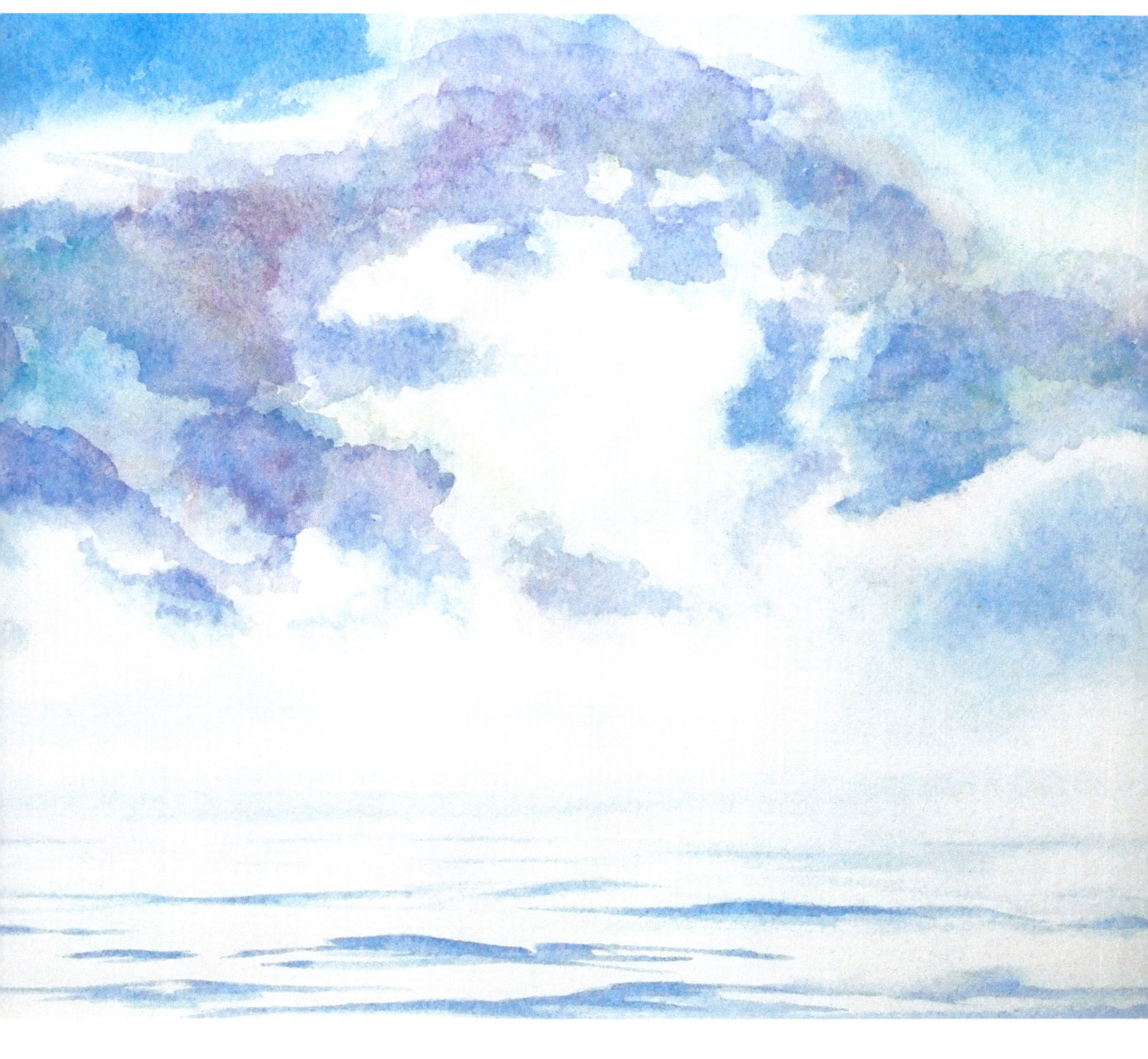

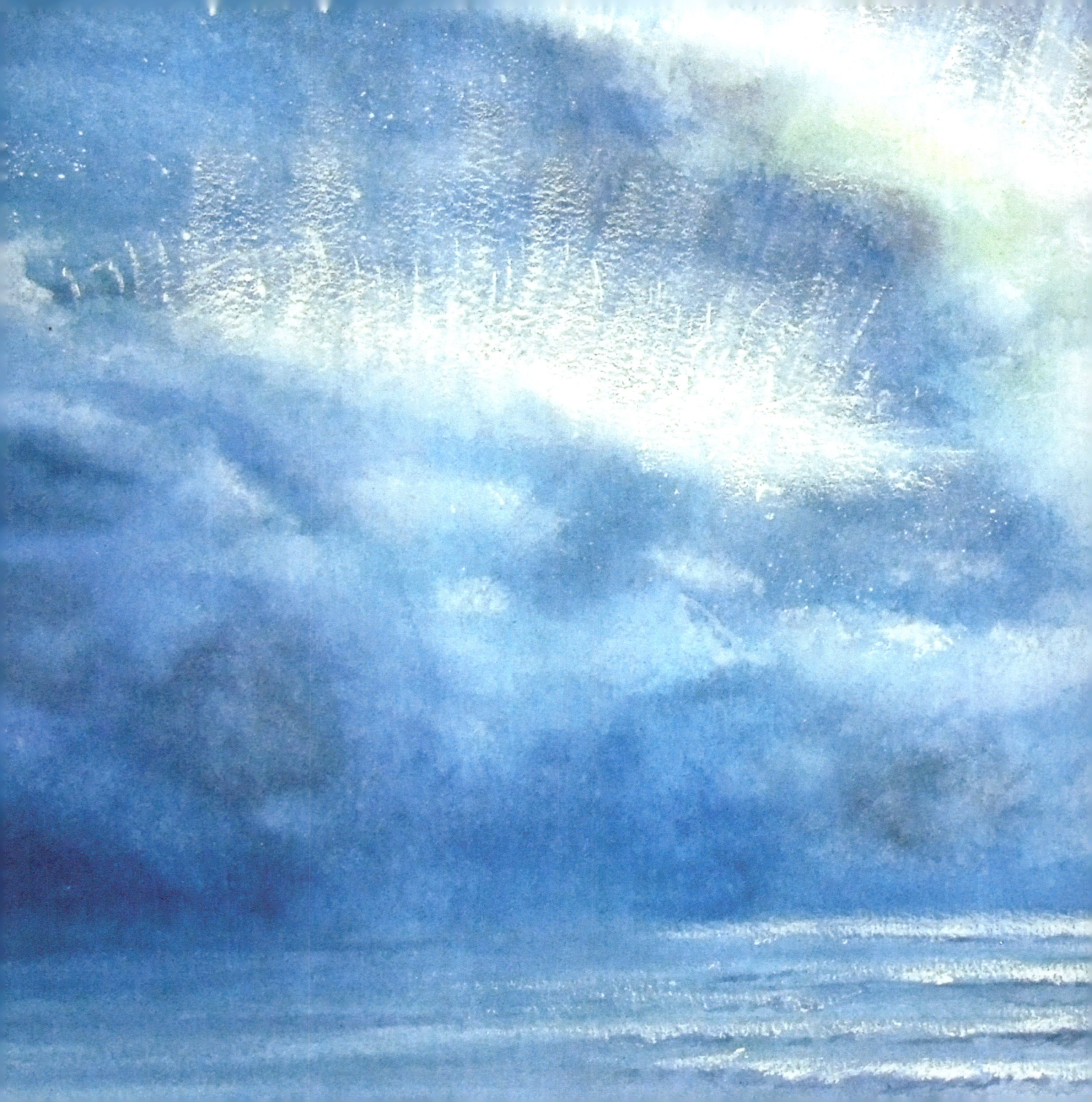

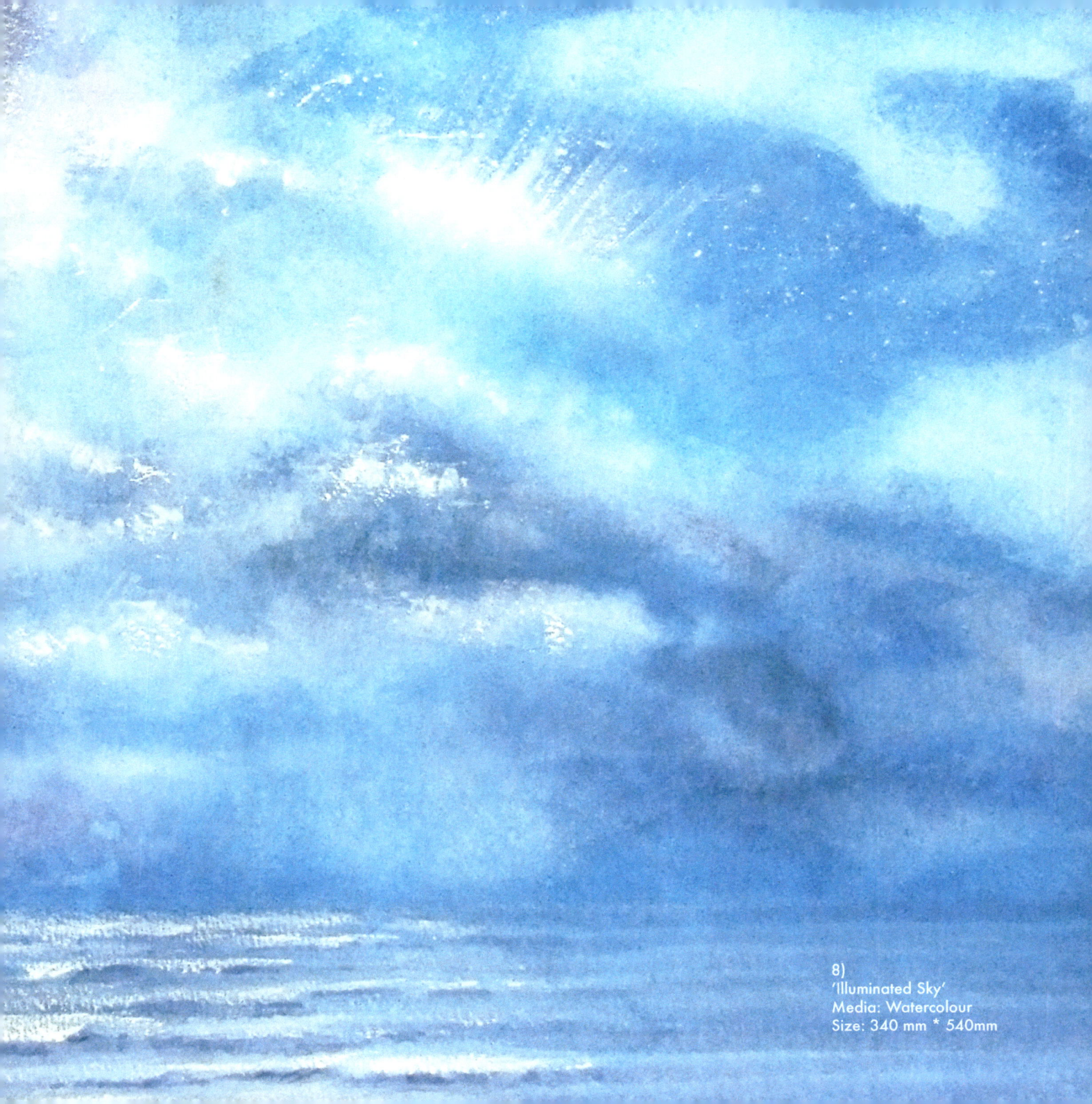

8)
'Illuminated Sky'
Media: Watercolour
Size: 340 mm * 540mm

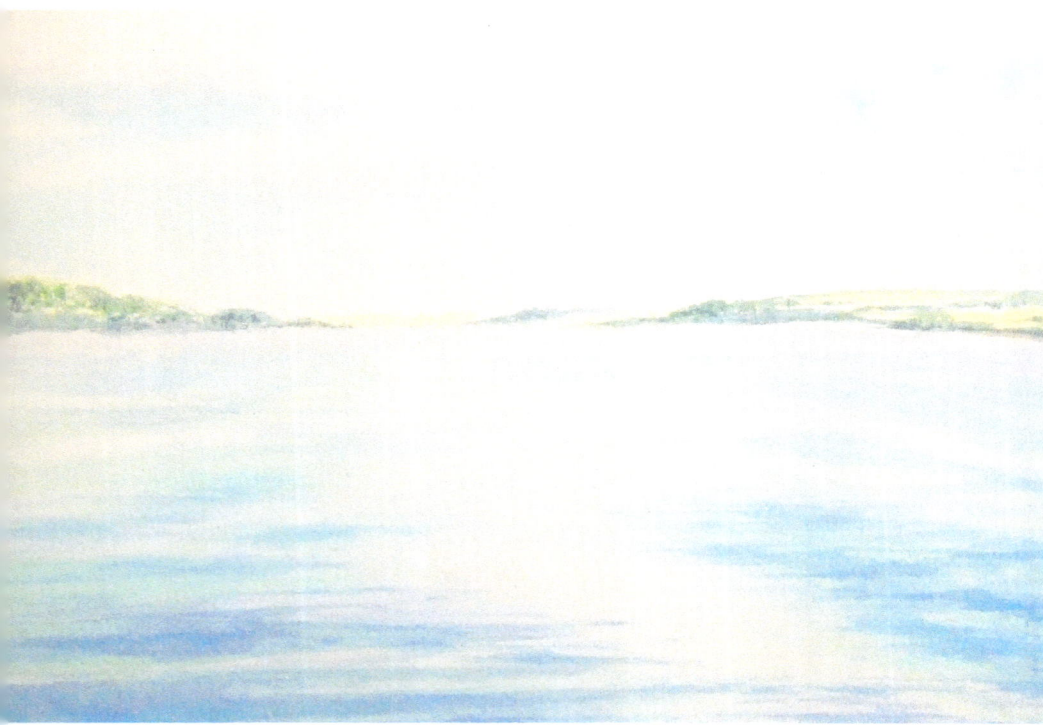

Rounding the headland of Saint Mawes we pass the castle. This fortification was commissioned by Henry the VIII in 1540. In partnership with Pendennis Castle that is located on the opposite side of the River Fal, these battlements were originally intended to protect the Carrick Roads against invasion from France and the Holly Roman Empire.

When easterly winds blow these waters offer little shelter, and during wild weather often the seas batter the inner harbour. This is a place where the river comes face to face with the elements.

9) Page Left
'Entering The River'
Media: Watercolour
Size: 340 mm * 540 mm

10) Page Right
'Saint Mawes'
Media: Pencil
Size: 340 mm * 540 mm

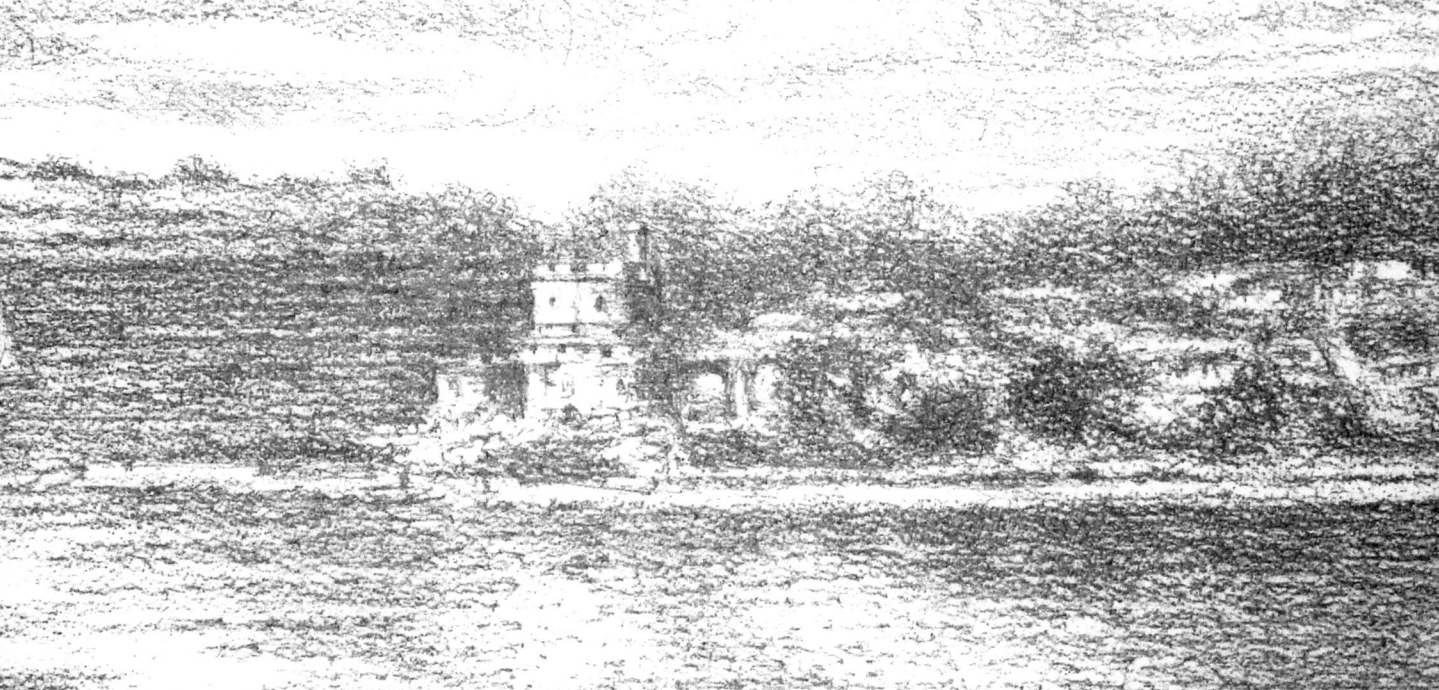

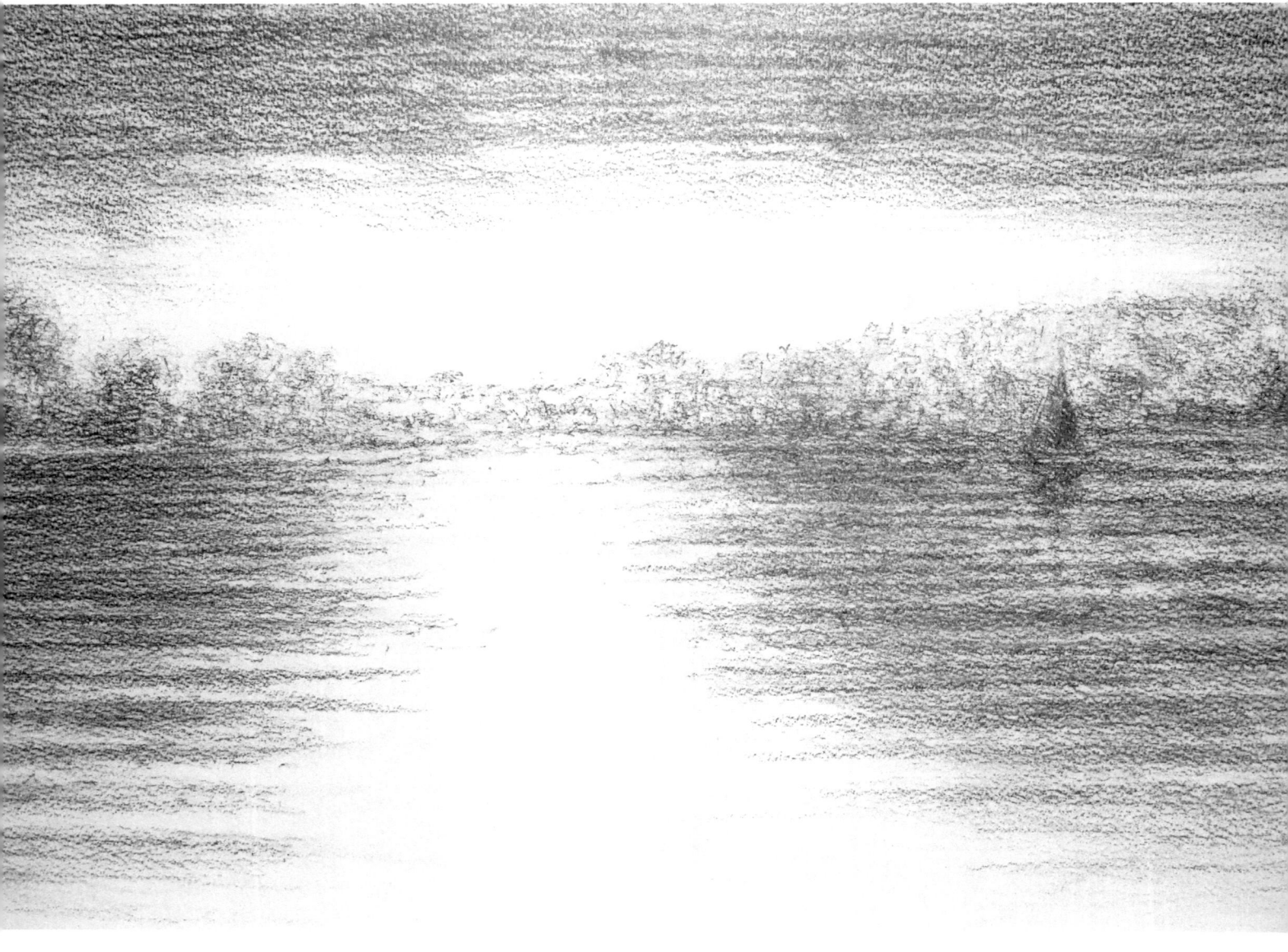

11) Page Left
'Sailing The Carrick Roads'
Media: Pecil
Size: 340 mm * 540 mm

Instantaneously rendering impressions of that which surrounds us is never overly easy. From a boat it is even more difficult. The water's surface and it's relationship with the sky is a marriage that lends itself well to picture making.

The artist could sketch or paint the same scene thousands of times and never twice would it be the same. This fact is a wonderful thing but the problem is that the changes that occur happen so fast. Just a small alteration of the light, or in the weather and the vision is entirely different.

The would-be picture maker of nature needs to work very fast and be able to hold a picture in their mind's eye until the image is down on paper.

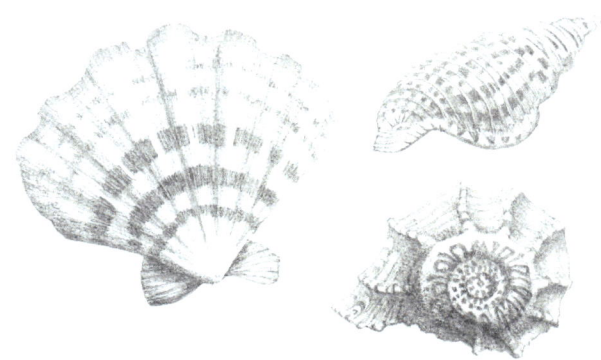

12) Page Right / Left
'Three Shells'
Media: Pencil
Size: 370 mm * 440 mm

13) Page Right / Right
'Simple Moon Reflection'
Media: Watercolour
Size: 540 mm * 340 mm

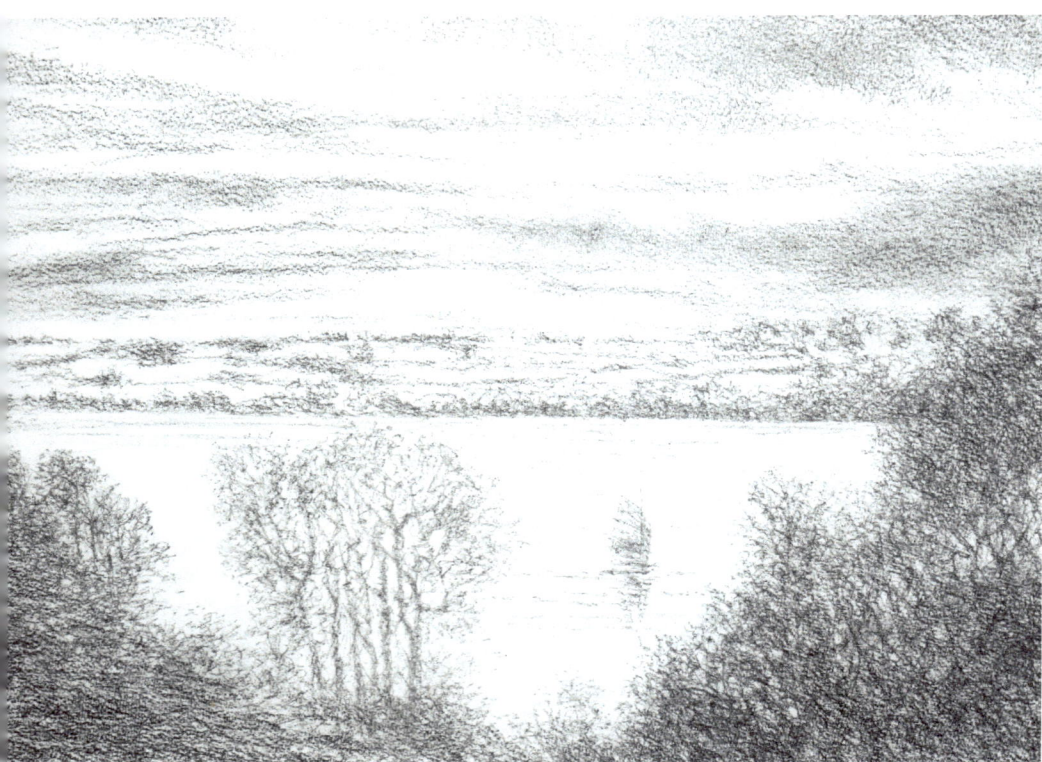

On occasion I employ technology to help me to study viewpoints that otherwise would not be possible. With the use of a quad-copter and a flying camera I can put my line of sight above the tops of the trees. An underwater camera affords me visual access to what is happening below the surface of the water.

Some art purists shun the use of such technology, My reply to such criticism is: 'Is it permissible for picture makers to wear corrective lenses if they have failing eyesight?'

14) Page Left
'Junk Rig On The River'
Media: Pencil
Size: 340 mm * 540 mm

15) Page Right
'Breaking Wave - Underwater'
Media: Watercolour
Size: 340 mm * 540 mm

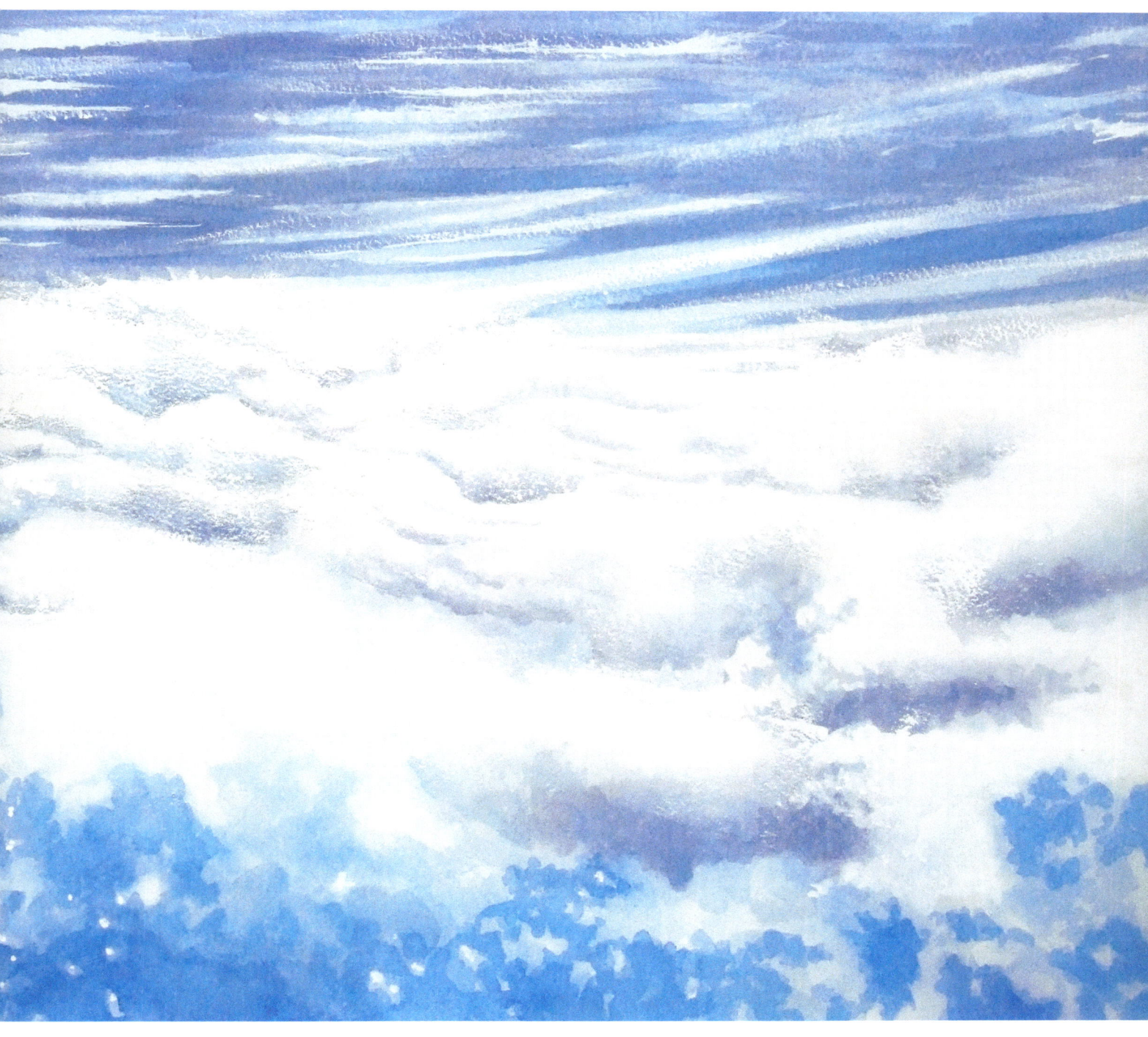

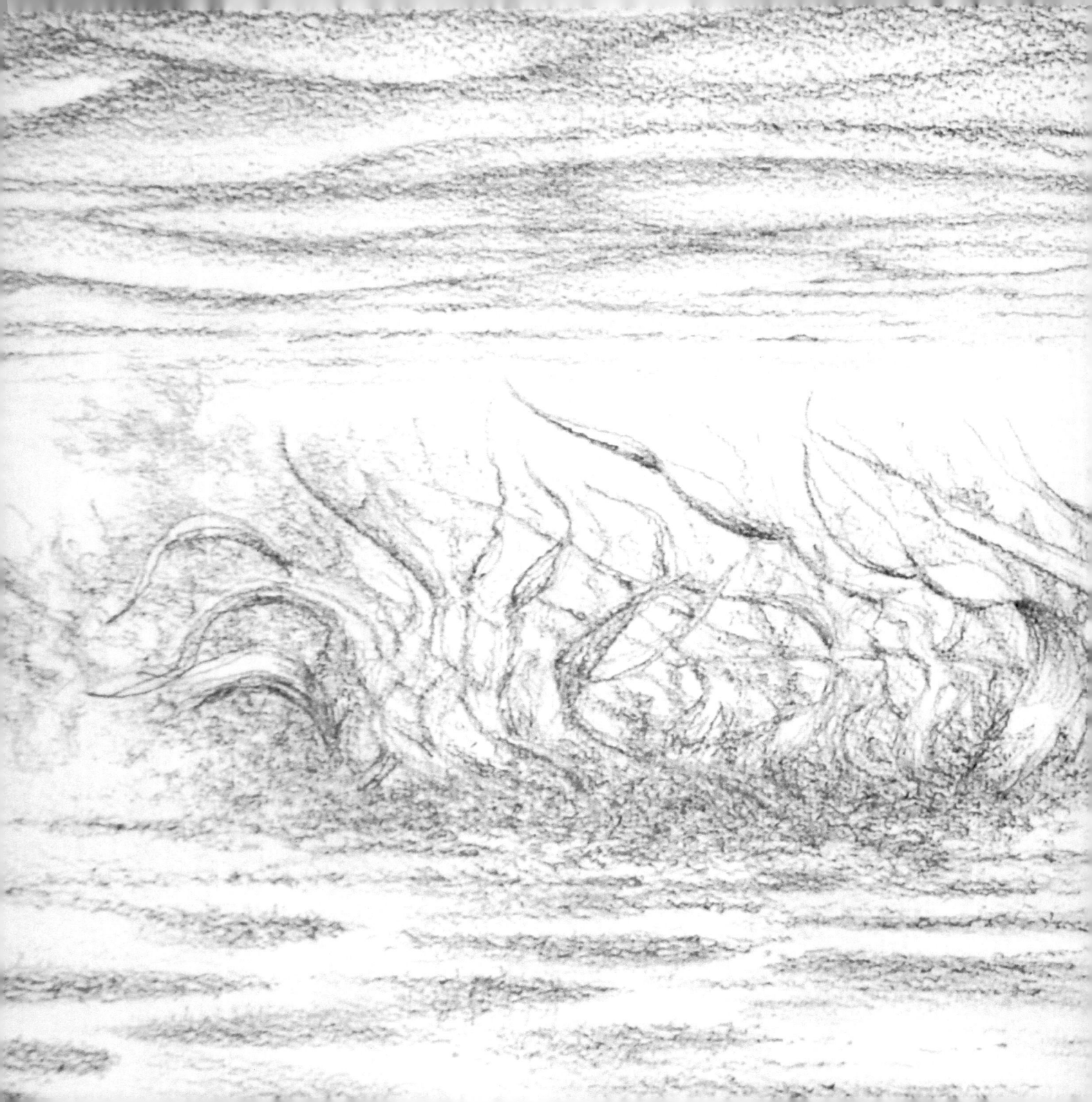

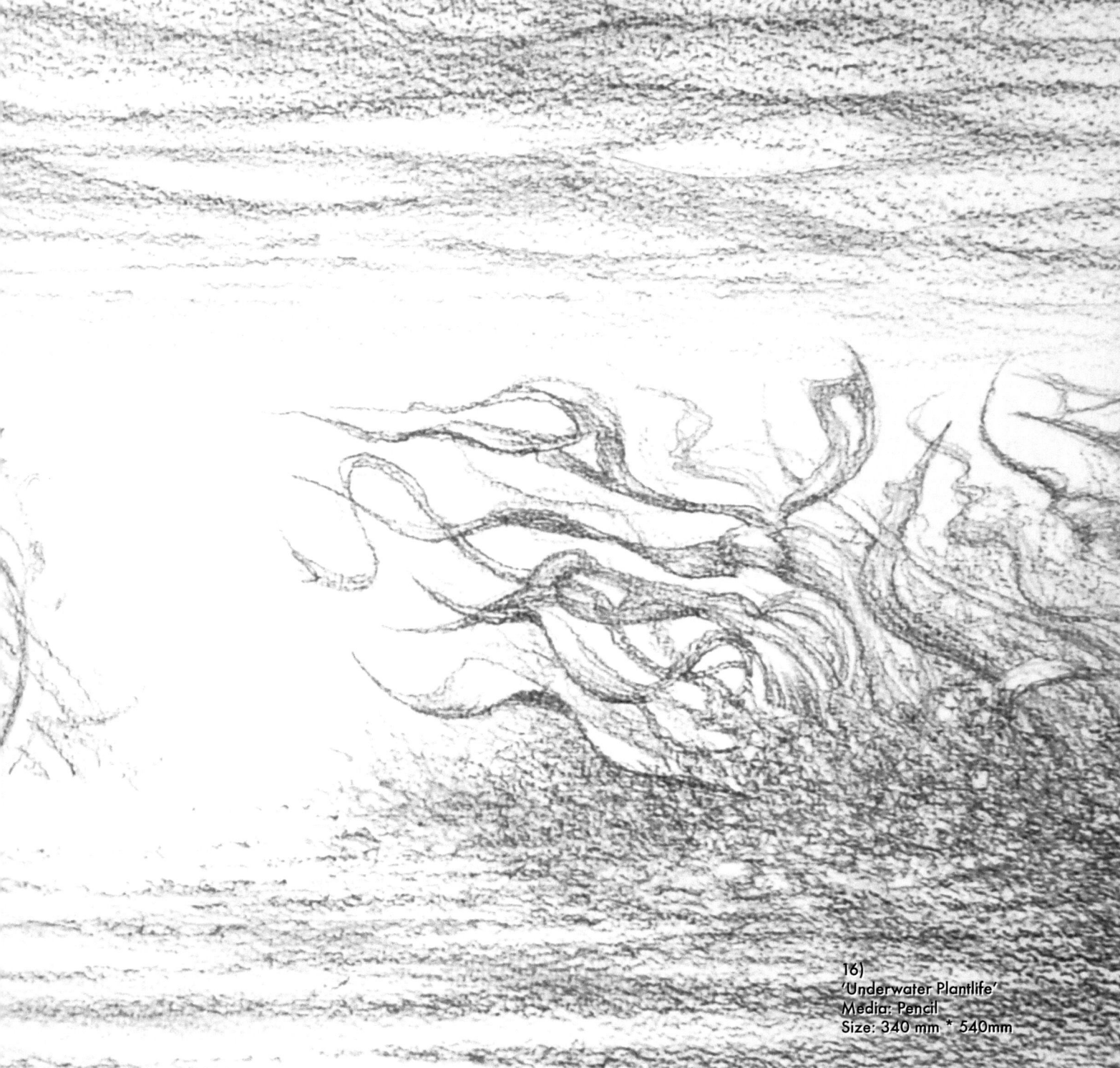

16)
'Underwater Plantlife'
Media: Pencil
Size: 340 mm * 540mm

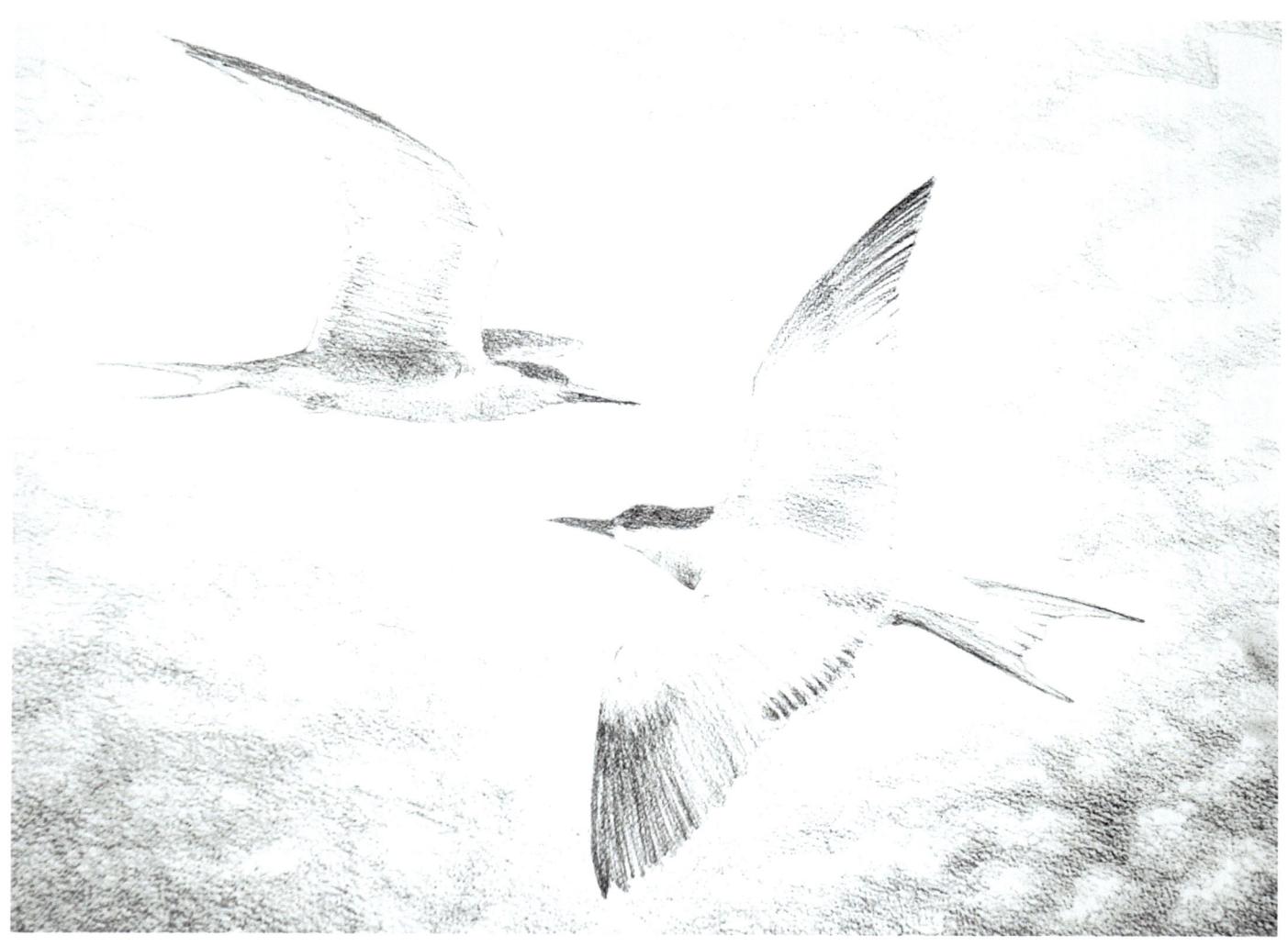

When I was a boy the only way to practice the drawing and painting of wildlife was to visit the Museum of Natural History, or to copy from photographs. Unfortunately, because the subject matter was inevitably inanimate the results were doomed to be lifeless. These days things are very differnt.

17) Page Left
'Terns In Flight'
Media: Pencil
Size: 340 mm * 540 mm

The age of recording moving image has allowed artists to study the world around us while it is in motion, and in environments that are alien to us. This luxury enables the picture makers more opportunities of bringing life and motion into their art.

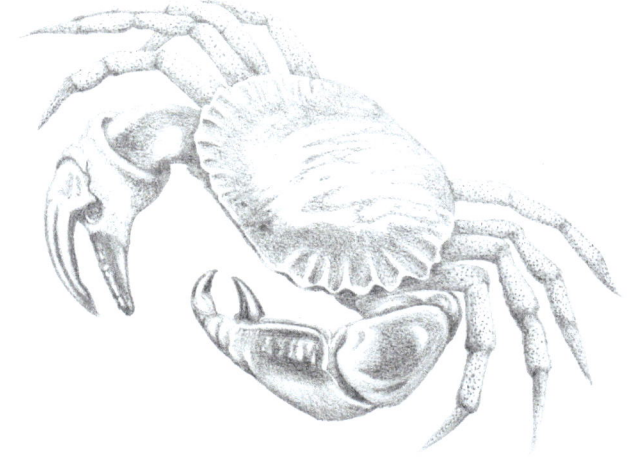

18) Page Right / Top
'Under The Surface'
Media: Watercolour
Size: 340 mm * 540 mm

19) Page Right / Bottom
'Crab'
Media: Pencil
Size: 370 mm * 440 mm

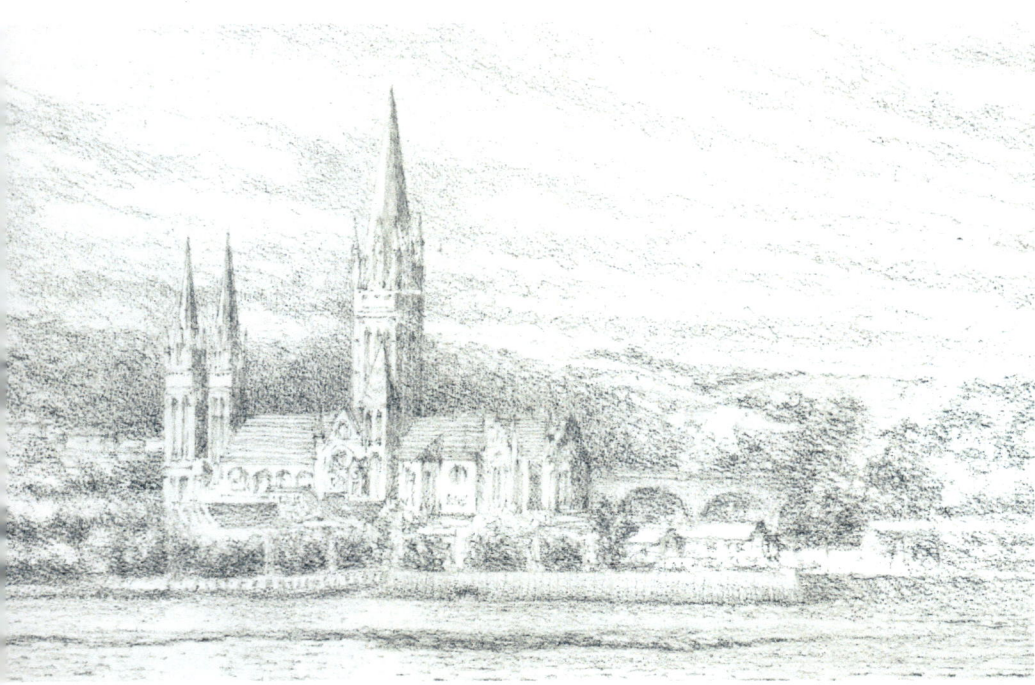

Following North along the Carrick Roads the Truro River meets the tidal path of the estuary. This river becomes no longer navigable when the three spires of Truro Cathedral dominates the skyline. Truro is the Capital City of Cornwall. The Anglican Cathedral of the Blessed Virgin Mary was designed in the style of Gothic Revival by John Loughborough Pearson and built between 1880 and 1910.

From here we turn around and follow the river back towards Falmouth, but not without finding the time to explore the riverbanks. These waters are greatly favoured by ornithologists and birdwatchers. Various waders visit here during summer and autumn, and kingfishers and egrets can be seen all year around.

20) Page Left
'Truro Cathedral'
Media: Pencil
Size: 340 mm * 540 mm

21) Page Right
'Rockpools & Rocks'
Media: Pencil
Size: 340 mm * 540 mm

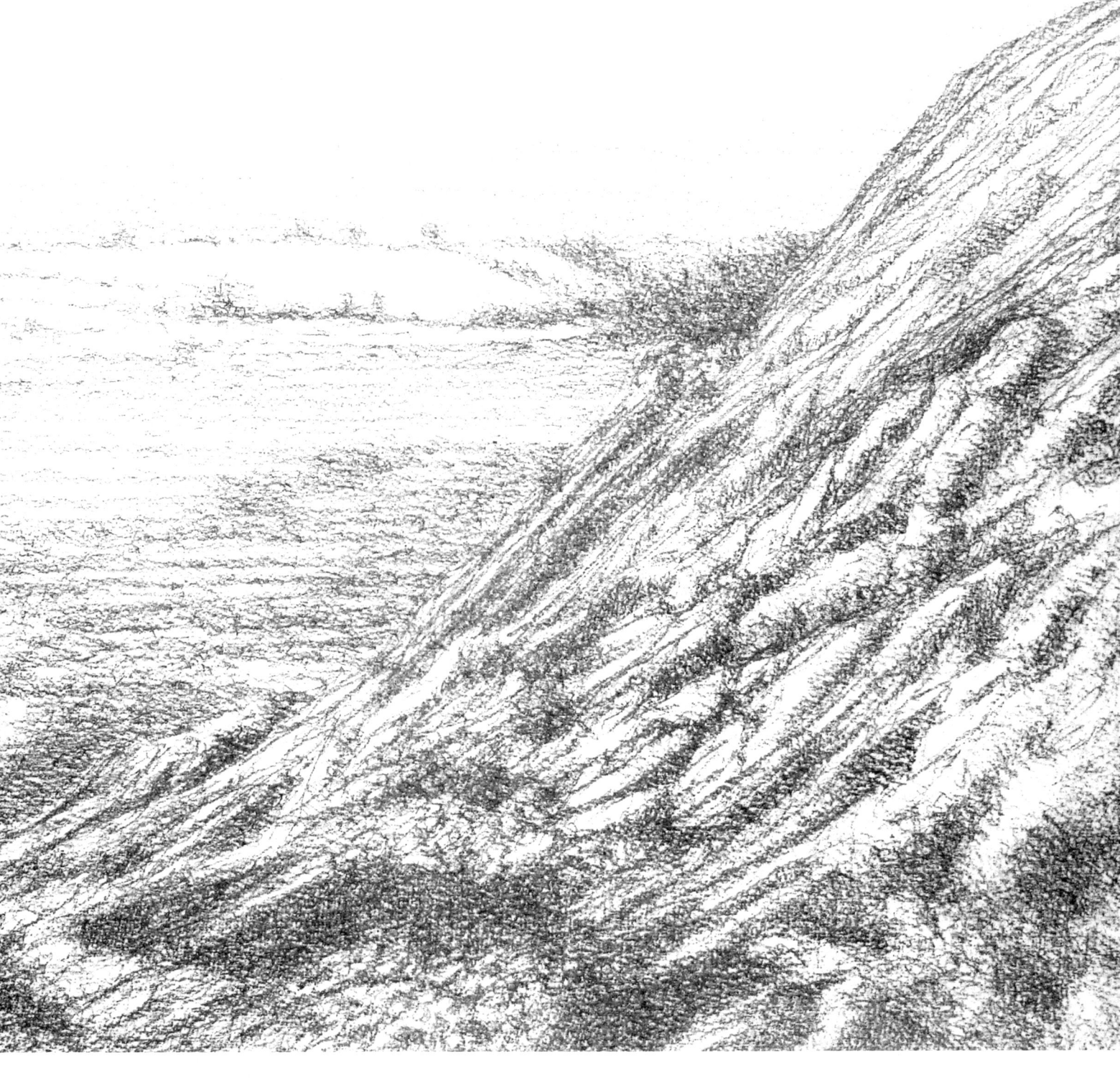

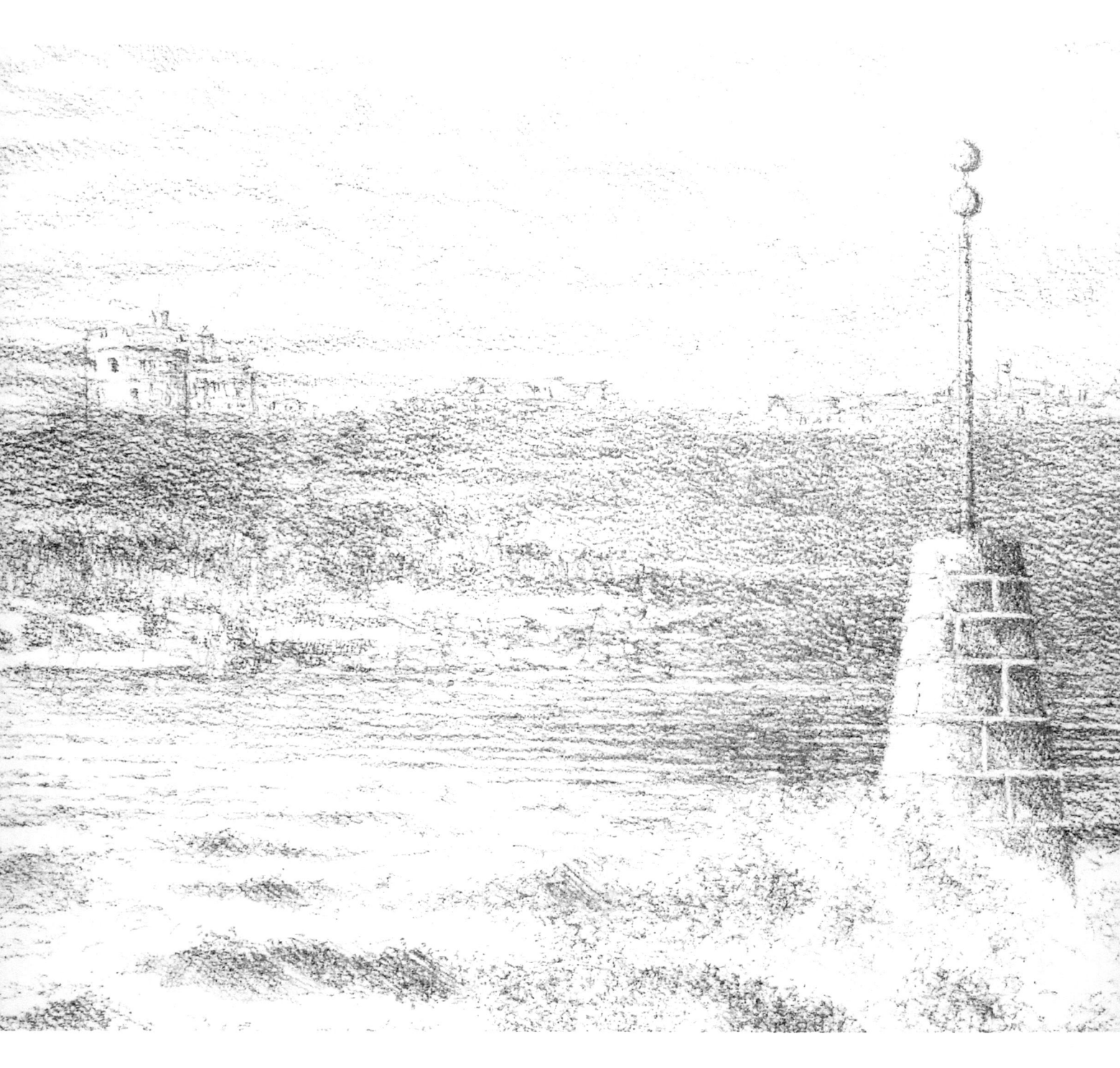

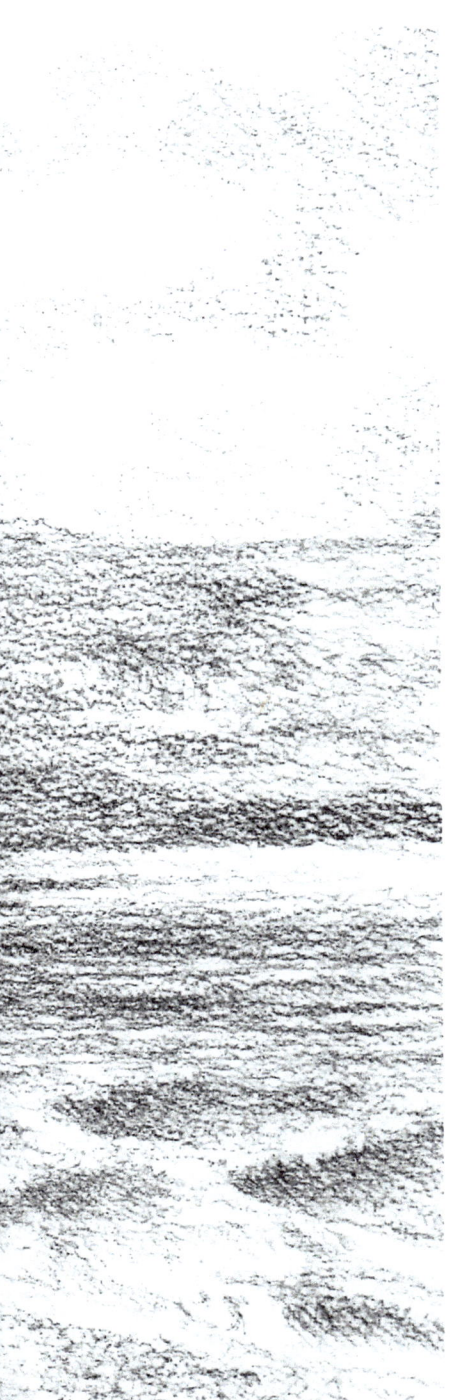
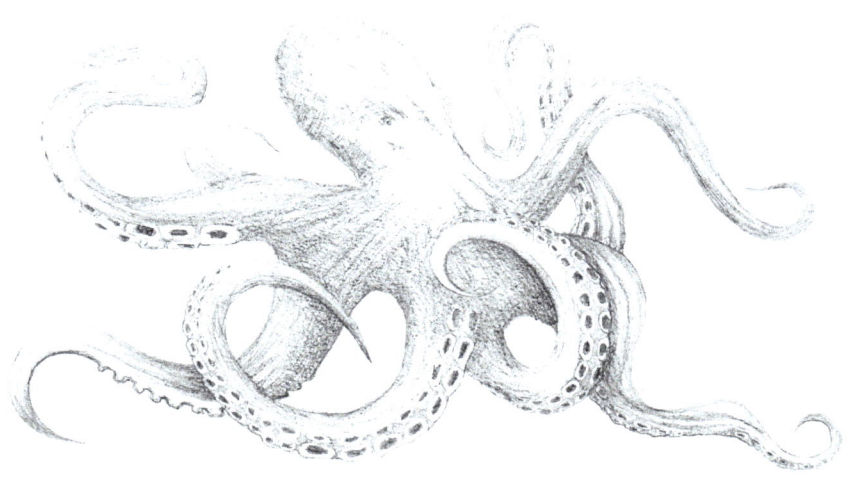

Having returned from an exploration of the Carrick Roads we find ourselves again insight of Saint Mawes. On the opposite side of the bay sits Pendennis Castle. Between Saint Anthony's Lighthouse and Pendennis Point is a most dangerous obstacle to shipping. This hazard is known as Black Rock. Although the rock itself is submerged at half tide it is clearly marked by a significant marker buoy.

This waypoint is a popular spot for sea-anglers and sport-fisherman alike but when at anchor there, keeping a sharp lookout is to be very well advised.

22) Page Left
'Black Rock'
Media: Pencil
Size: 340 mm * 540 mm

23) Page Right
'Octopus'
Media: Pencil
Size: 370 mm * 440 mm

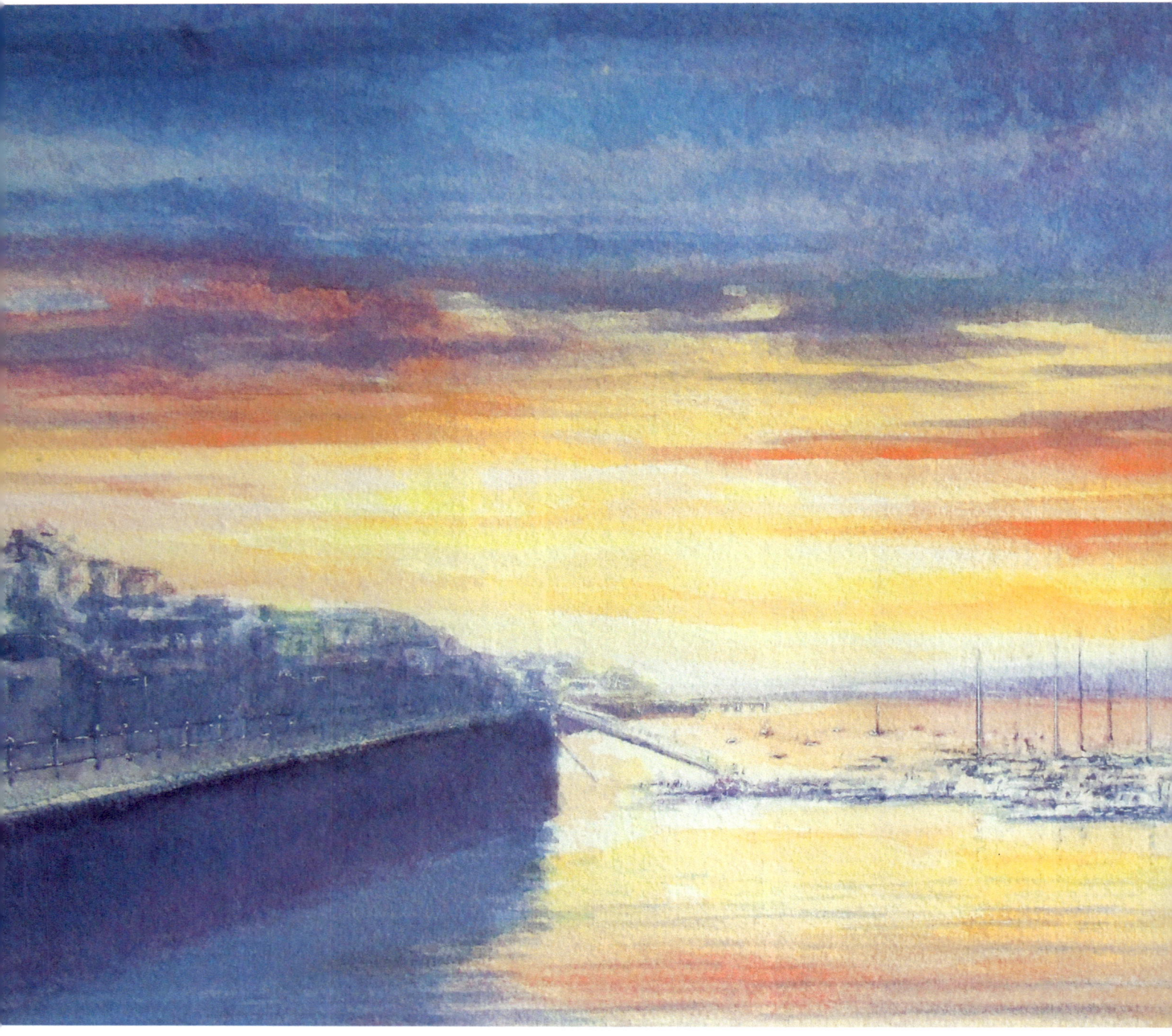

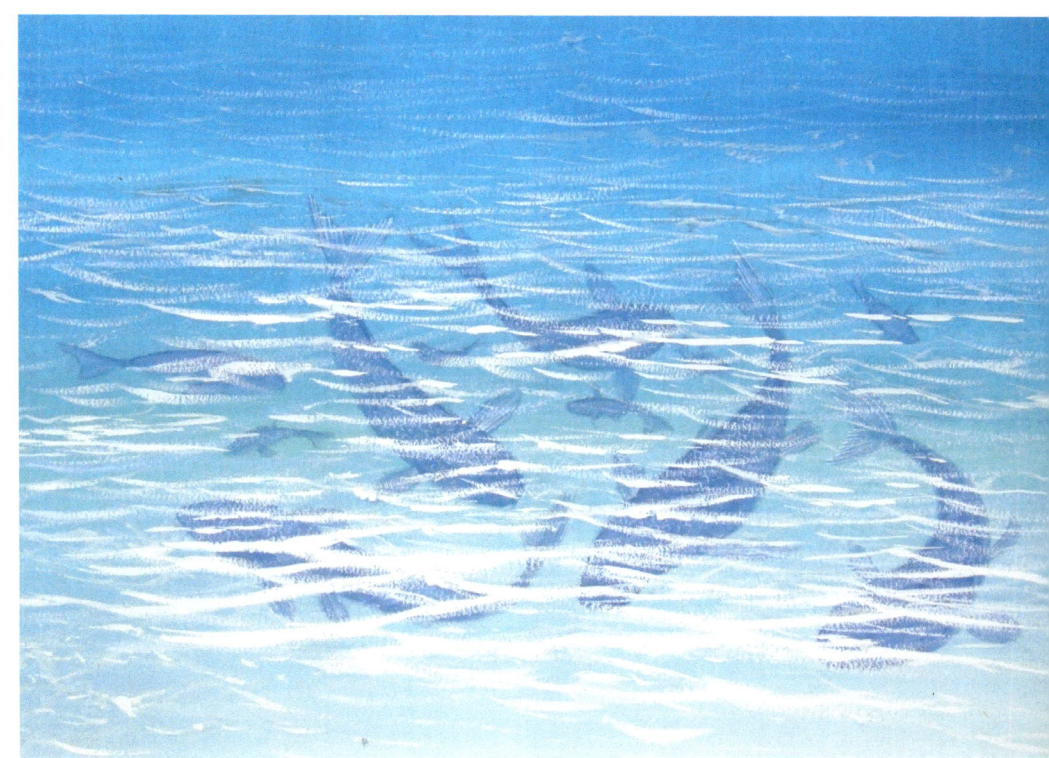

Entering the deep waters of Falmouth Harbour the docks appear on the vessel's portside. The inner harbour offers visiting vessels a safe anchorage and the waterfront ashore affords visitors a sanctuary where all manner of essential supplies and luxuries can be found.

The town of Falmouth boasts a rich maritime history. For myself, it one of my most favourite ports in the world. It is also a great place to take timeout and just make a few pictures.

24) Page Left
'Falmouth Haven'
Media: Watercolour
Size: 340 mm * 540 mm

25) Page Right
'Fish Beneath The Surface'
Media: Watercolour
Size: 340 mm * 540 mm

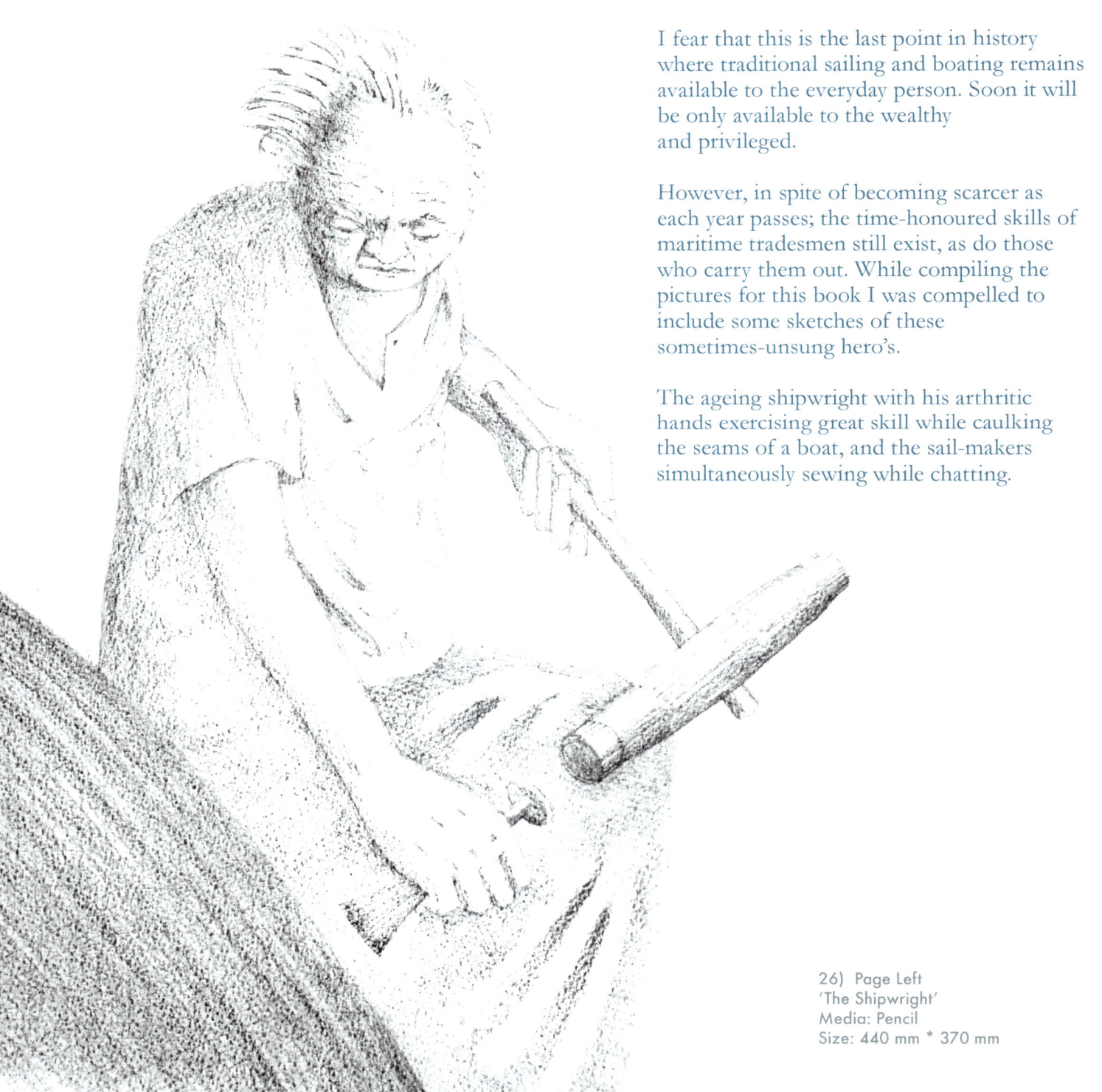

I fear that this is the last point in history where traditional sailing and boating remains available to the everyday person. Soon it will be only available to the wealthy and privileged.

However, in spite of becoming scarcer as each year passes; the time-honoured skills of maritime tradesmen still exist, as do those who carry them out. While compiling the pictures for this book I was compelled to include some sketches of these sometimes-unsung hero's.

The ageing shipwright with his arthritic hands exercising great skill while caulking the seams of a boat, and the sail-makers simultaneously sewing while chatting.

26) Page Left
'The Shipwright'
Media: Pencil
Size: 440 mm * 370 mm

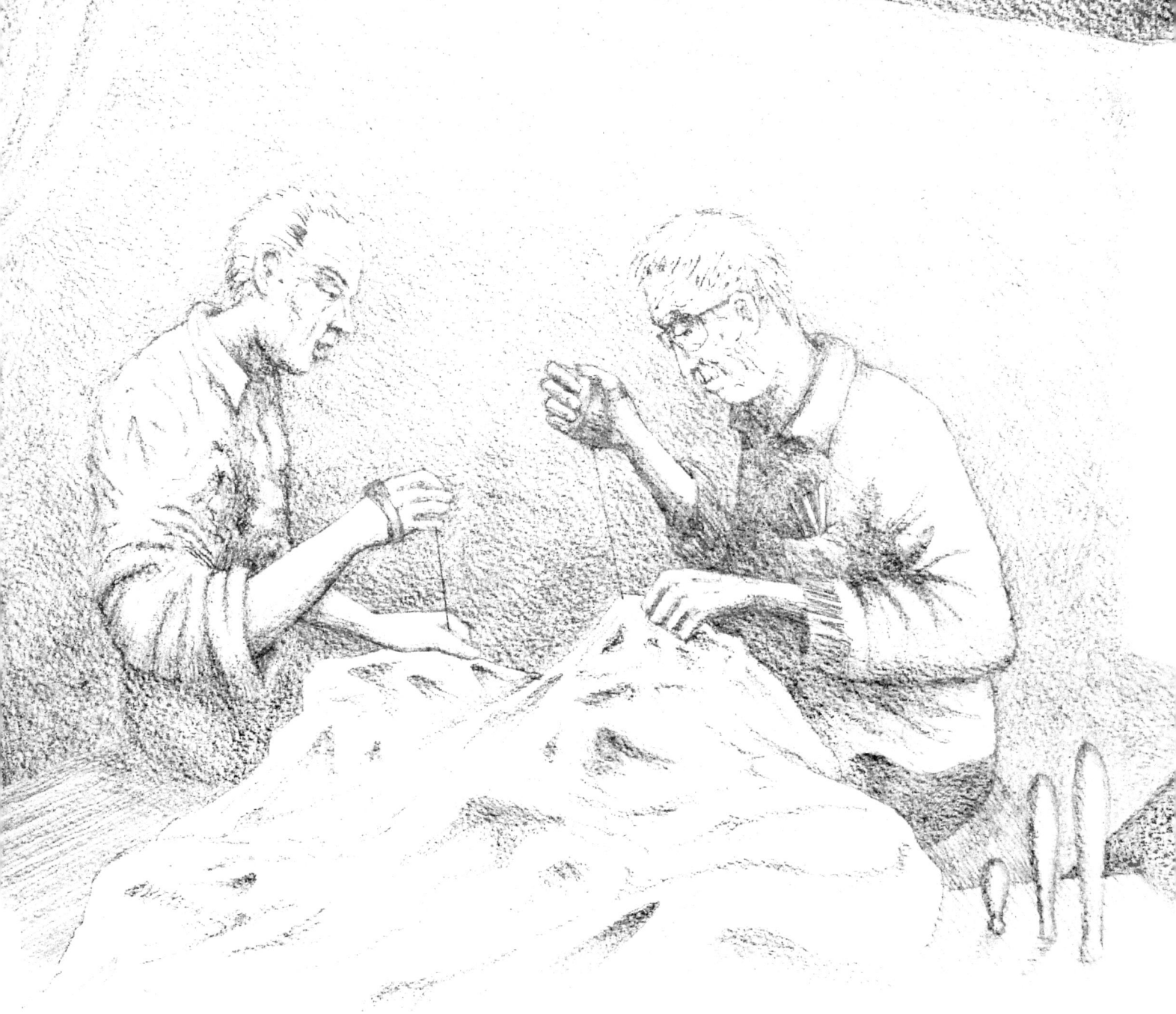

27) Page Right
'The Sailmakers'
Media: Pencil
Size: 370 mm * 440 mm

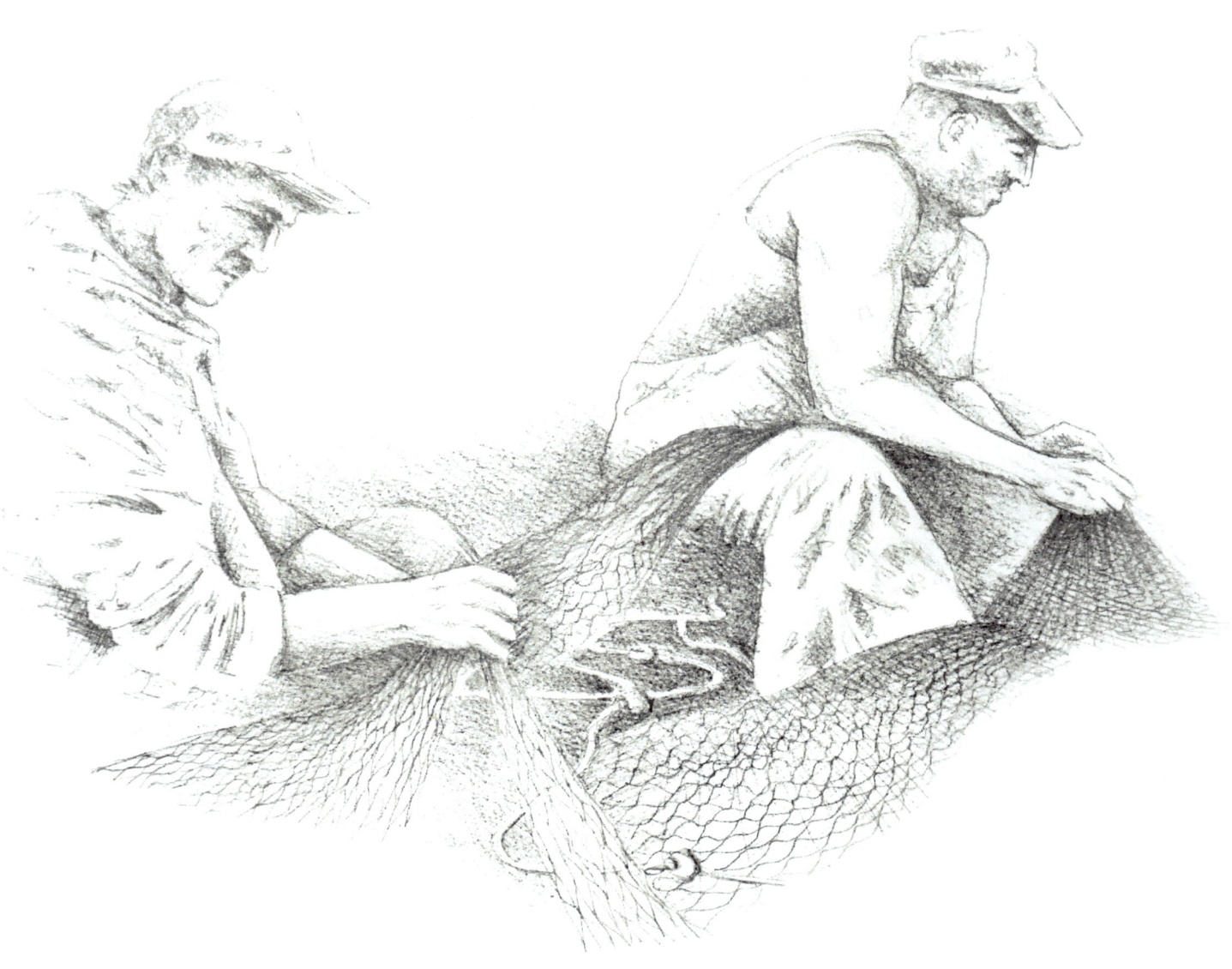

Although fishing from small vessels has been on the decline for the past few decades it does happily still persist along the shores all around the UK. This means of making a living remains as a harder task as it ever was but the financial rewards have persistently dropped in value. I personally greatly admire the heroism of those who risk their very lives to bring to us fish to accompany our chips.

28) Page Left
'Checking The Nets'
Media: Pencil
Size: 370 mm * 440 mm

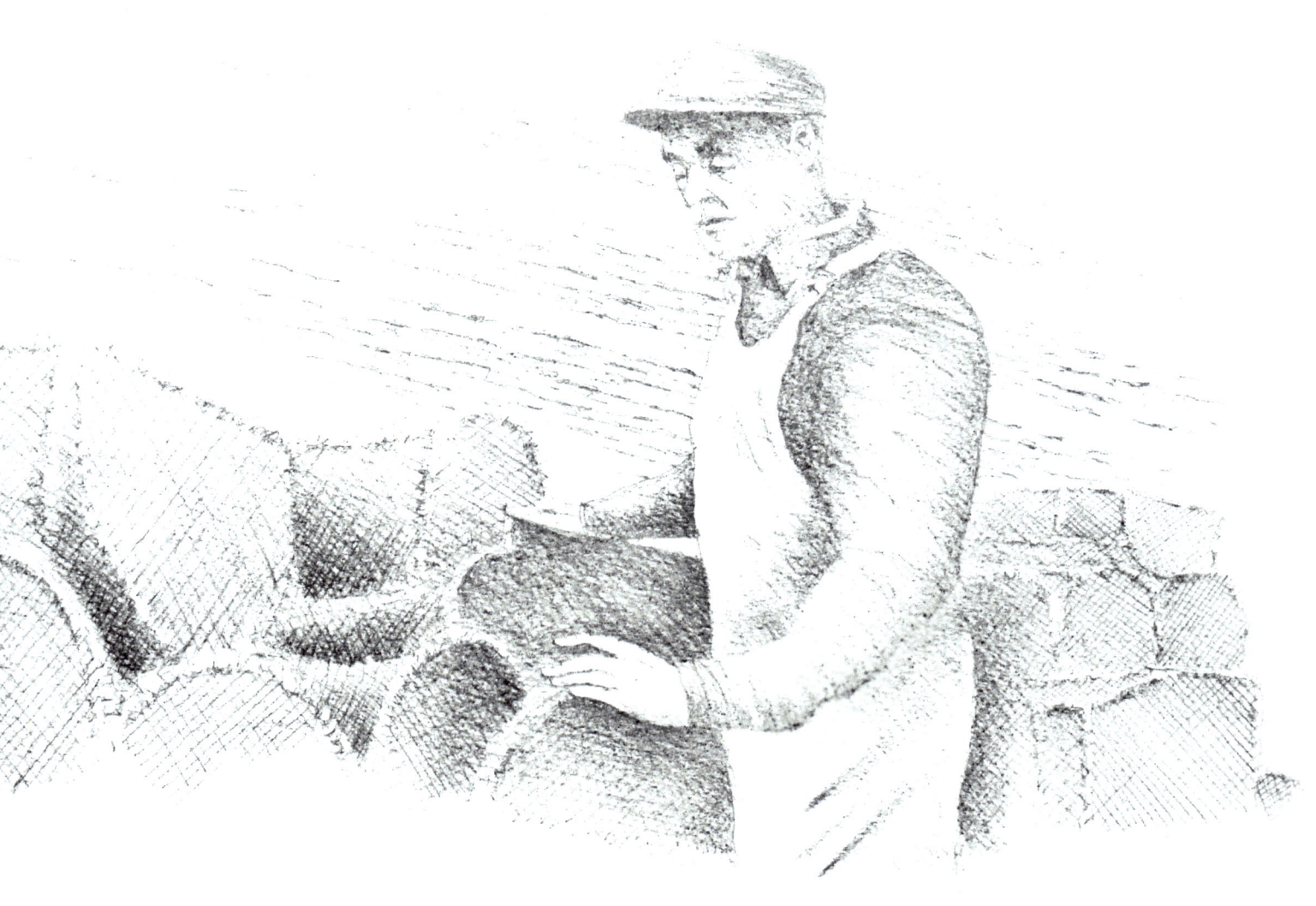

Understandably, superstitions run deep with seafarers and not least with fisherman. These guys are very often reluctant to being photographed or sketched but I was determined to include some drawings of them in this book. This picture of the skipper with his pots tells a subtle story. The language of his hands is not of counting the pots but more likely of blessing them.

29) Page Right
'Blessing The Pots'
Media: Pencil
Size: 370 mm * 440 mm

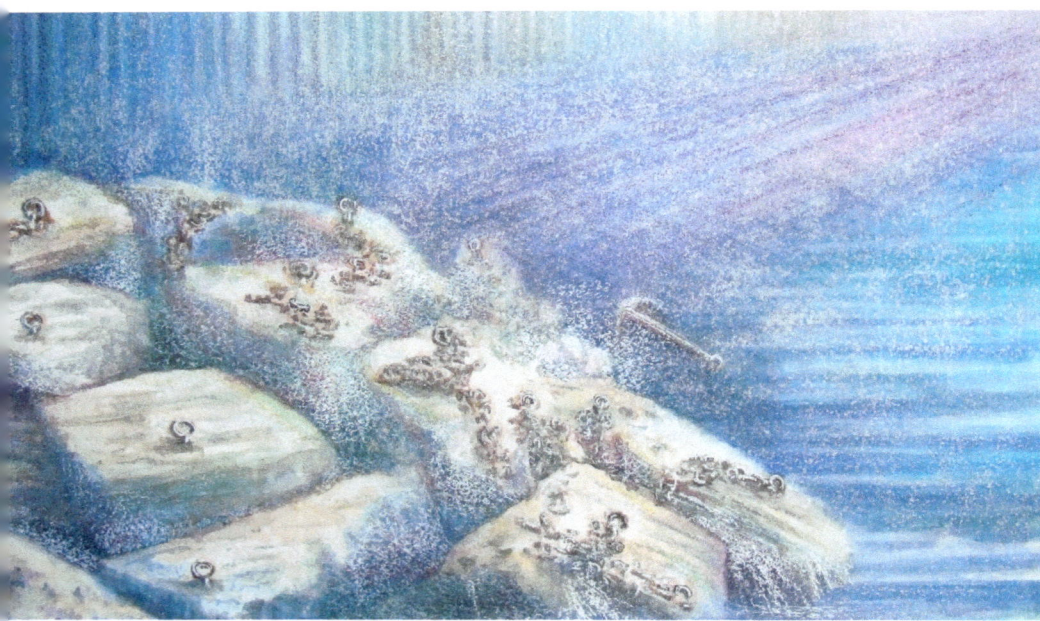

The Stone Bridge at Penryn marks the near furthest navigable point that can be reached along the river northwest of Falmouth. From here this book again takes the reader back to the mouth of the river and out to sea.

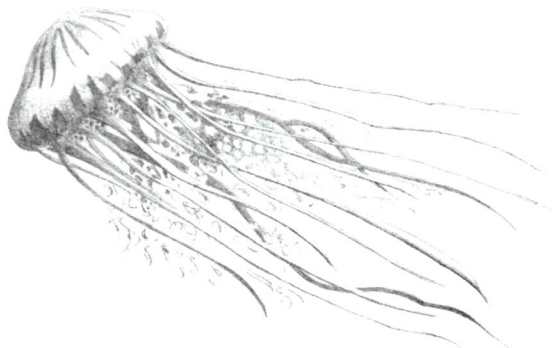

30) Page Left / Top
'Old Moorings'
Media: Watercolour
Size: 340 mm * 540 mm

31) Page Left / Bottom
'Compass Jellyfish'
Media: Pencil
Size: 370 mm * 440 mm

32) Page Right
'Penryn Bridge'
Media: Pencil
Size: 340 mm * 540 mm

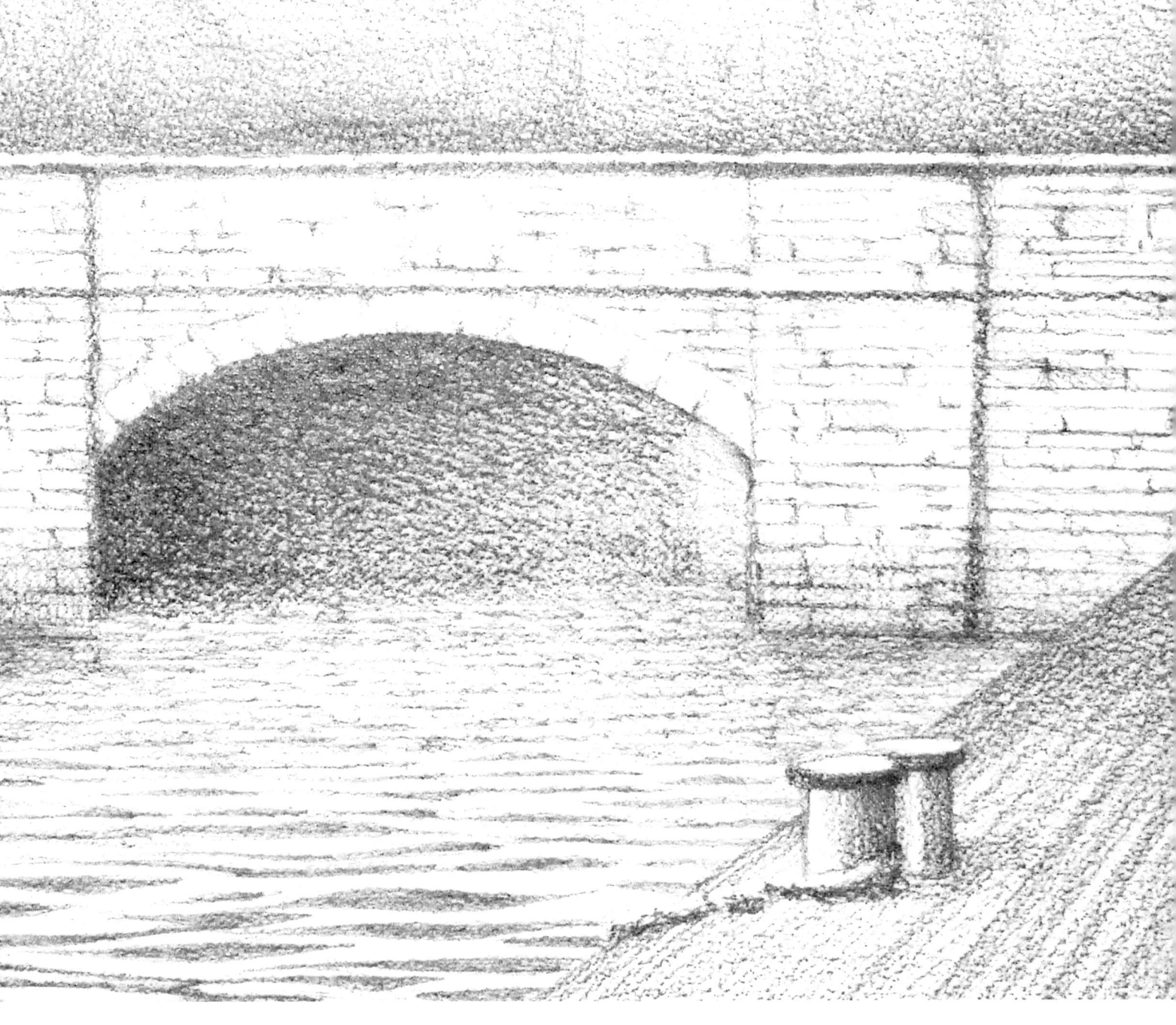

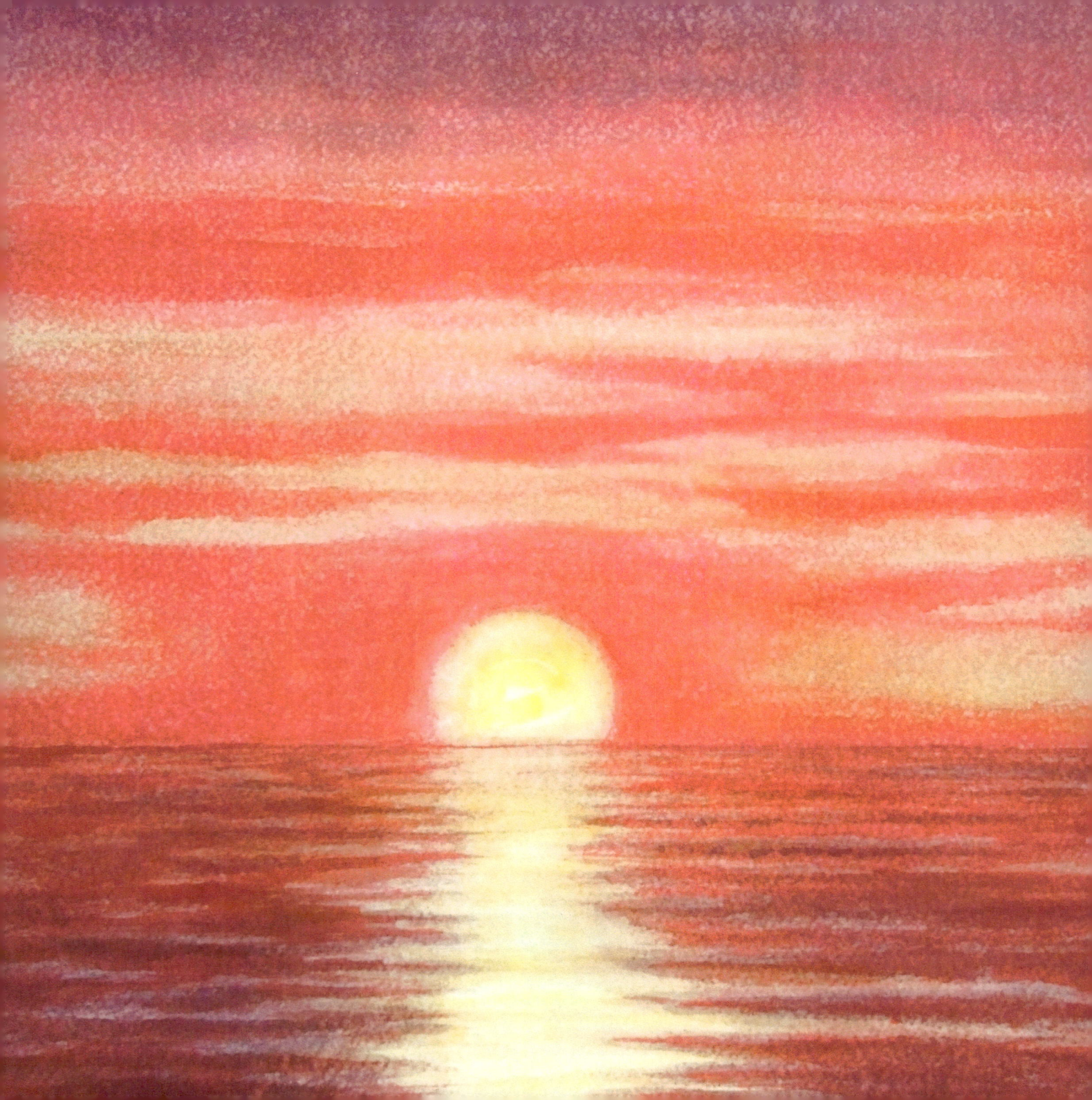

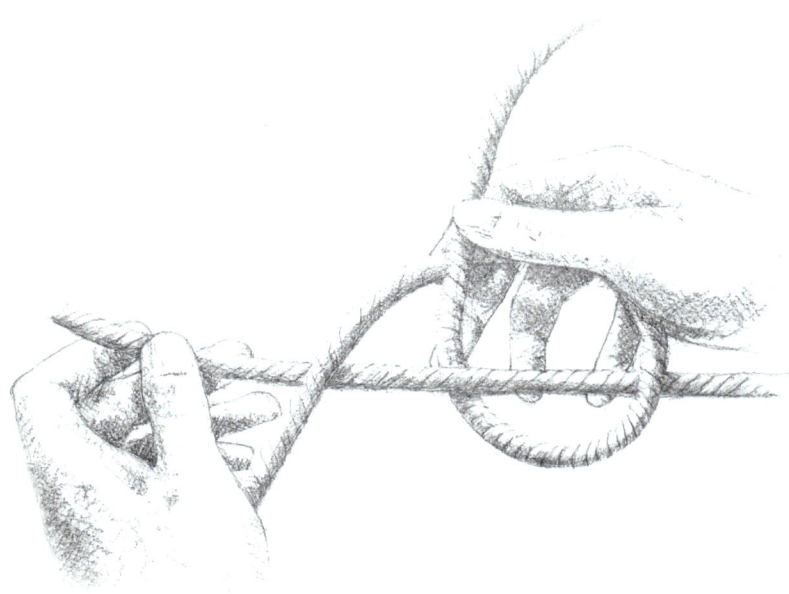

Any sailor worth his salt will agree that the Bowline is without question the most important and useful knot to be able to tie. It is advised that seafarers should be able to tie this knot in the dark and with both hands behind their back. I feel that the same applies to the would-be picture maker of skies and seascapes when it comes to sunsets and sunrises.

Most infant children make pictures before they master the spoken word. It is probably how we begin to comprehend and understand the world around us. Have you ever noticed how so many of those pictures created by small children include an icon of the sun?

33) Page Left
'Red Sky At Sea'
Media: Watercolour
Size: 340 mm * 540 mm

34) Page Right
'King Of Knots'
Media: Pencil
Size: 370 mm * 440 mm

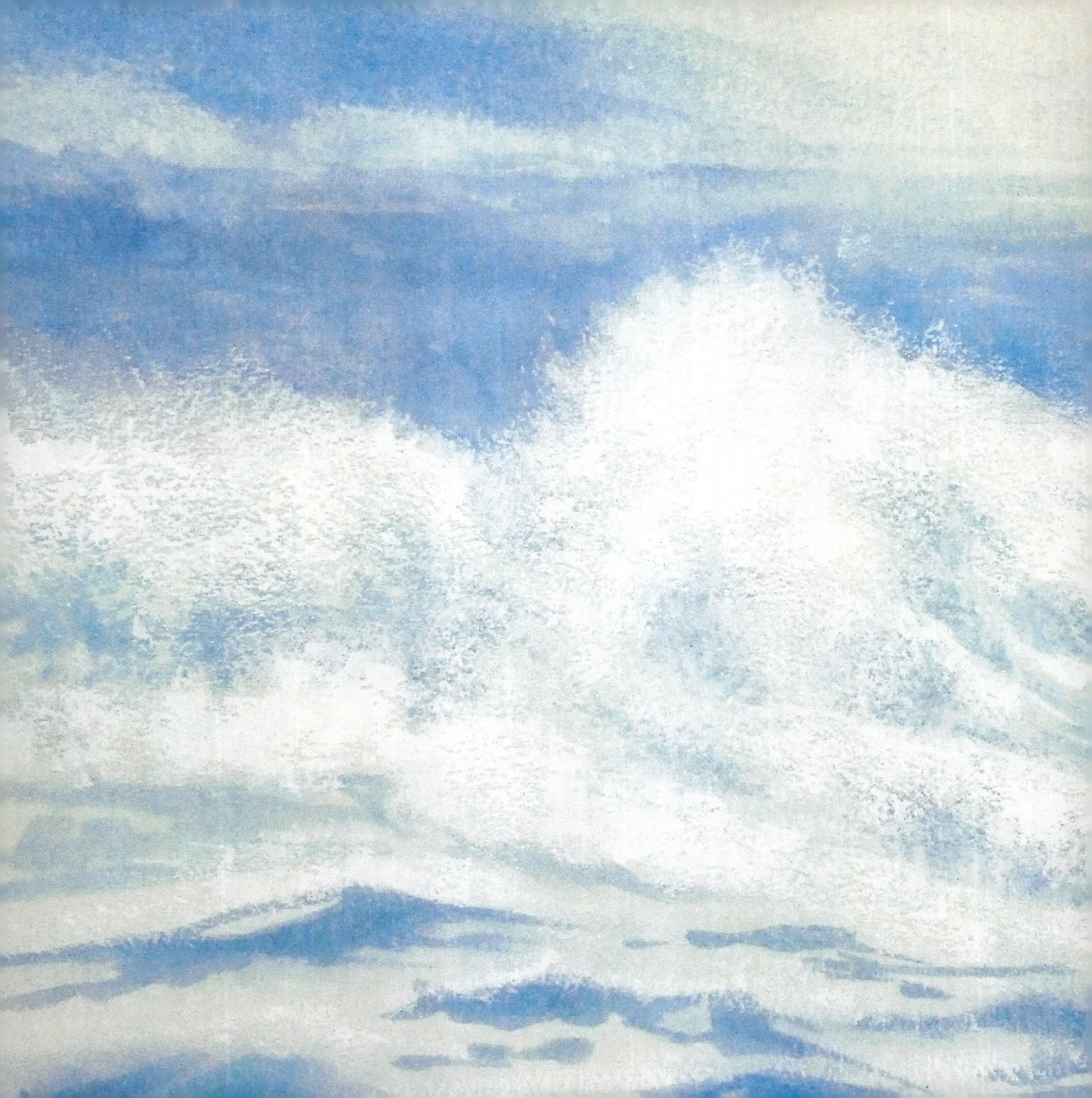

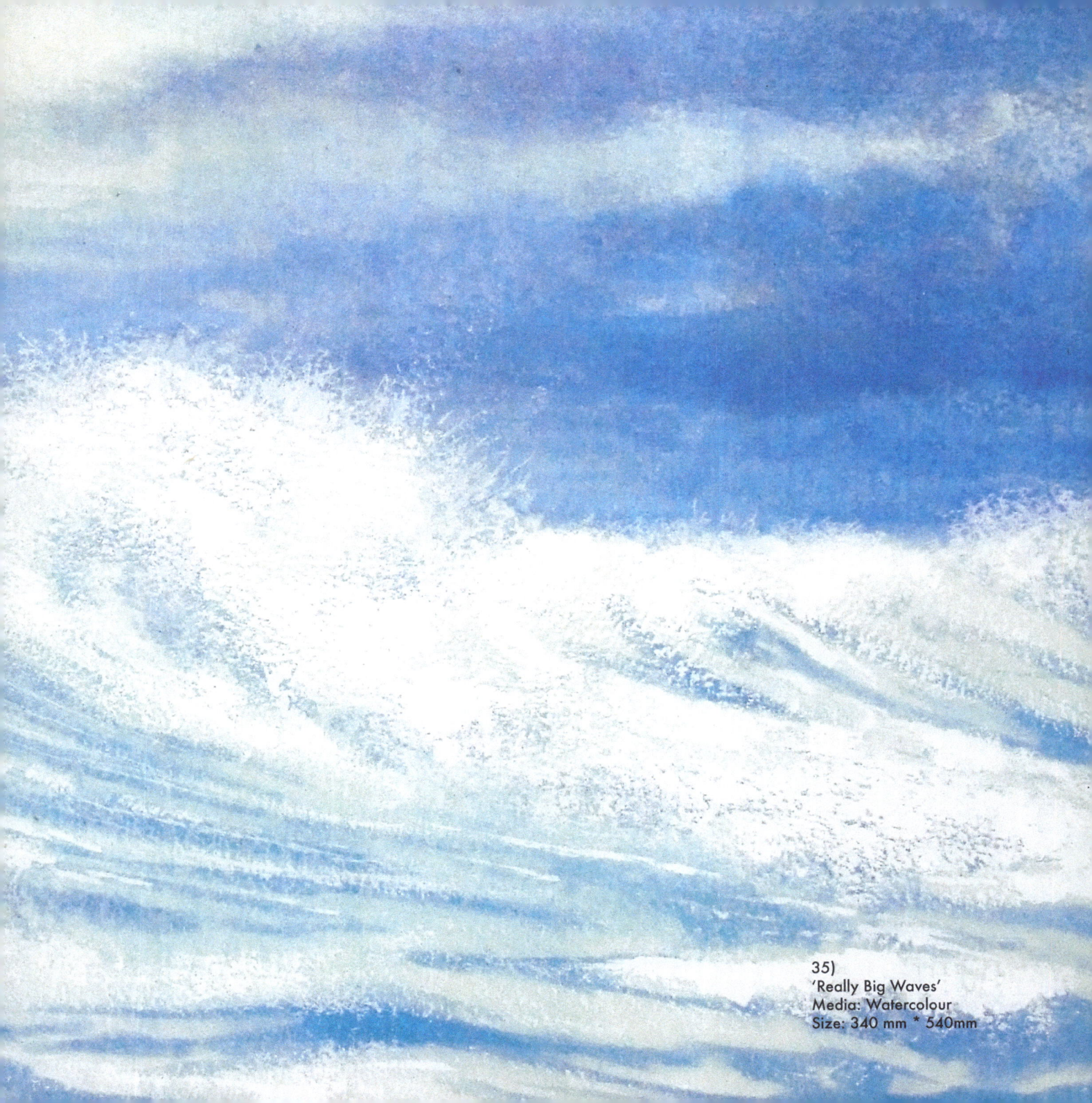

35)
'Really Big Waves'
Media: Watercolour
Size: 340 mm * 540mm

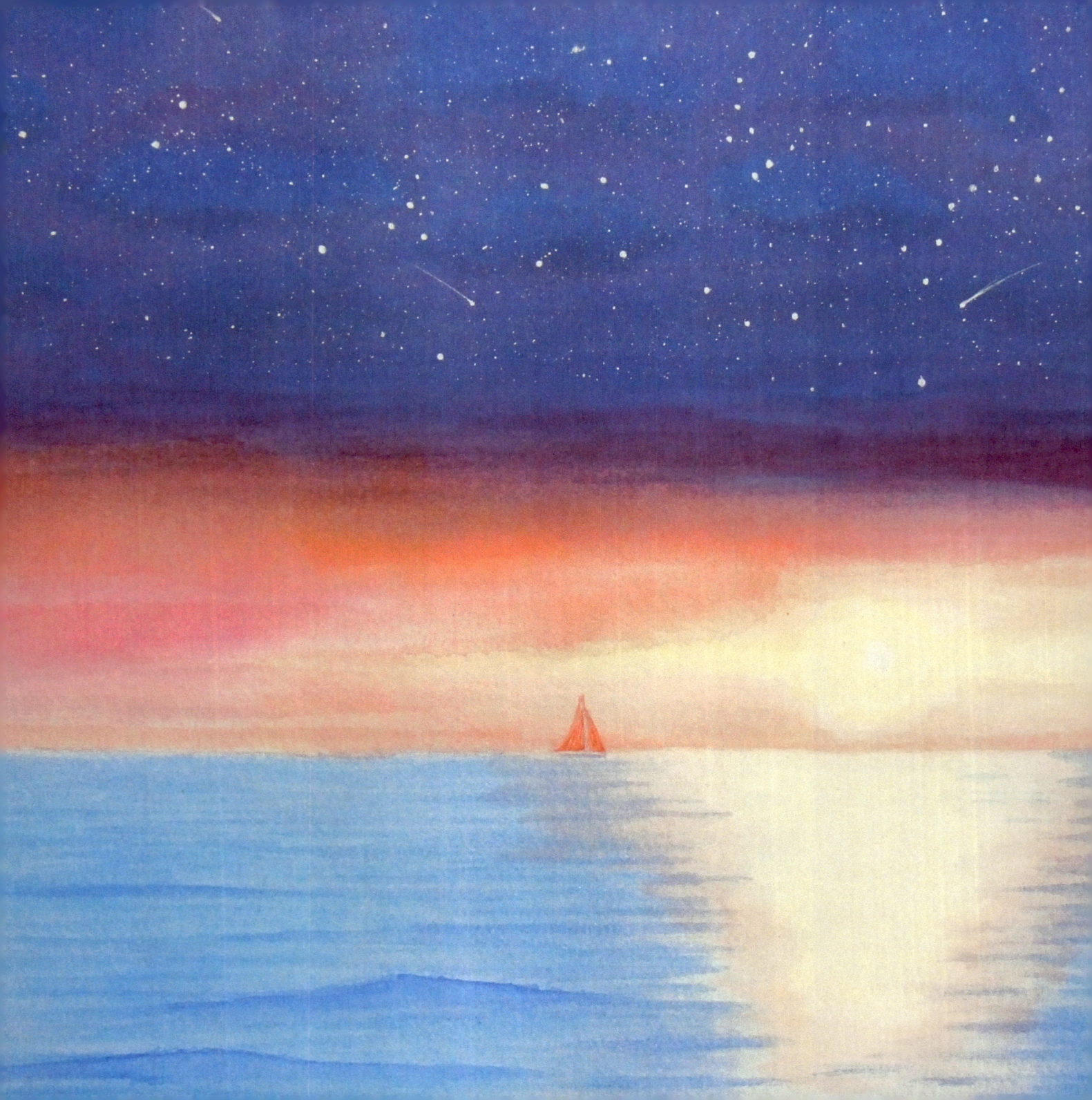

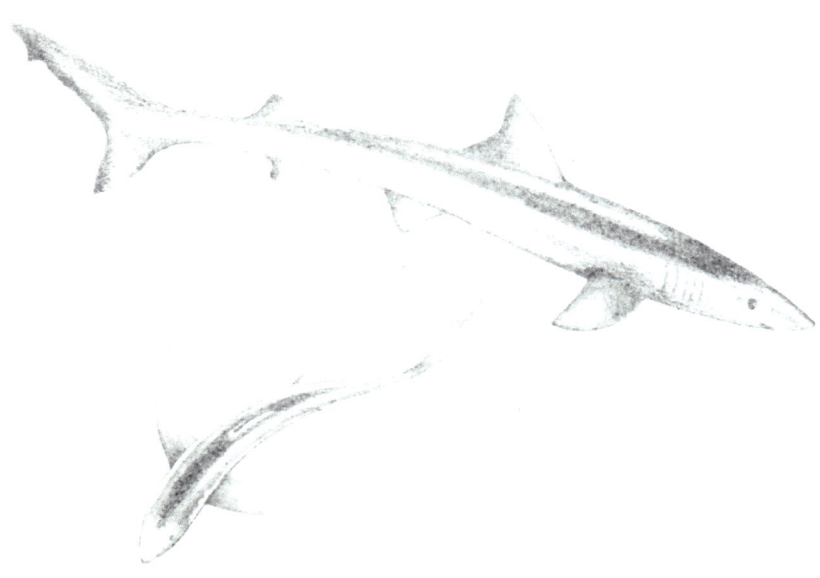

Only the star-filled night sky and a vast ocean beneath it adequately highlights to us just how small and insignificant we humans really are. The whole scheme of things is far beyond our comprehension but when considering such vastness it is impossible to not acknowledge that our lives are like a single grain of sand being blown across the desert.

With the knowing of below the ocean's surface exists many life forms, and the mystery of if or not life as we understand it exists up there among the heavens, The gift of picture making is not a skill, it is a privilege.

36) Page Left
'Calm Sea And Shooting Stars'
Media: Watercolour
Size: 340 mm * 540 mm

37) Page Right
'Smoothhounds'
Media: Pencil
Size: 370 mm * 440 mm

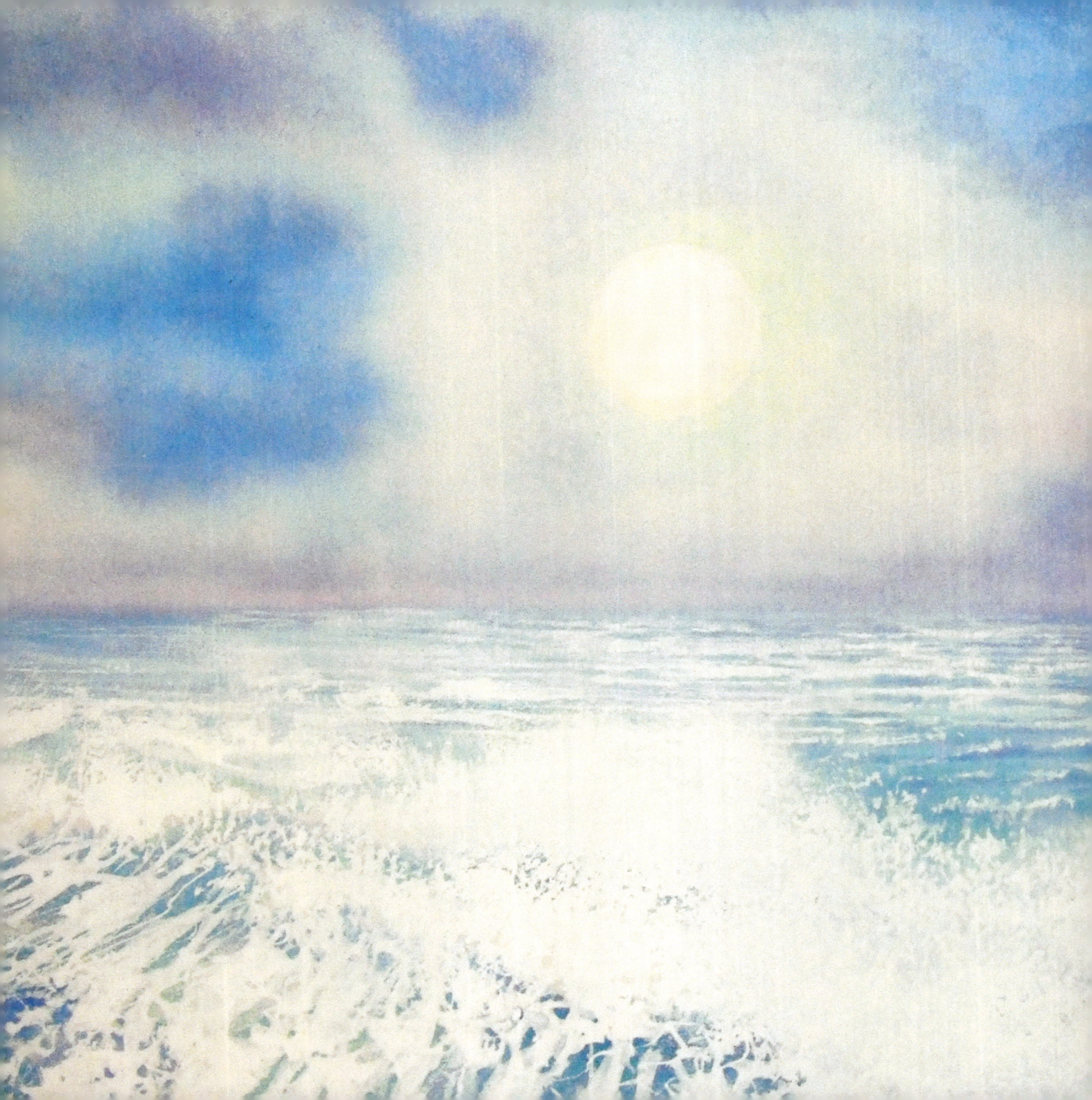

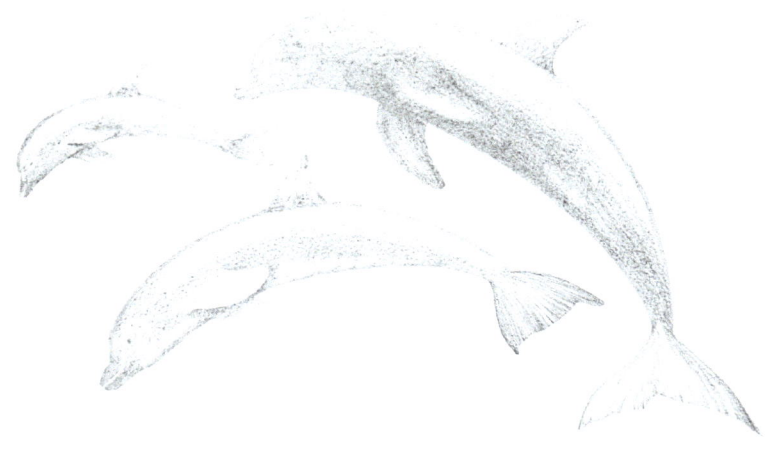

Just as does a boat crossing an ocean, the passage of our lives leaves behind a trail of the path taken. Although our wake may exist for only a short while it affects all that is around us. The wave that we leave behind is capable of causing disruption or sometimes even harm but it can also attract wonderful and beautiful things towards us.

It is impossible to capture our own wake but the picture maker is licenced to replicate it.

38) Page Left
'In My Wake'
Media: Watercolour
Size: 340 mm * 540 mm

39) Page Right
'Three Leaping Dolphins'
Media: Pencil
Size: 370 mm * 440 mm

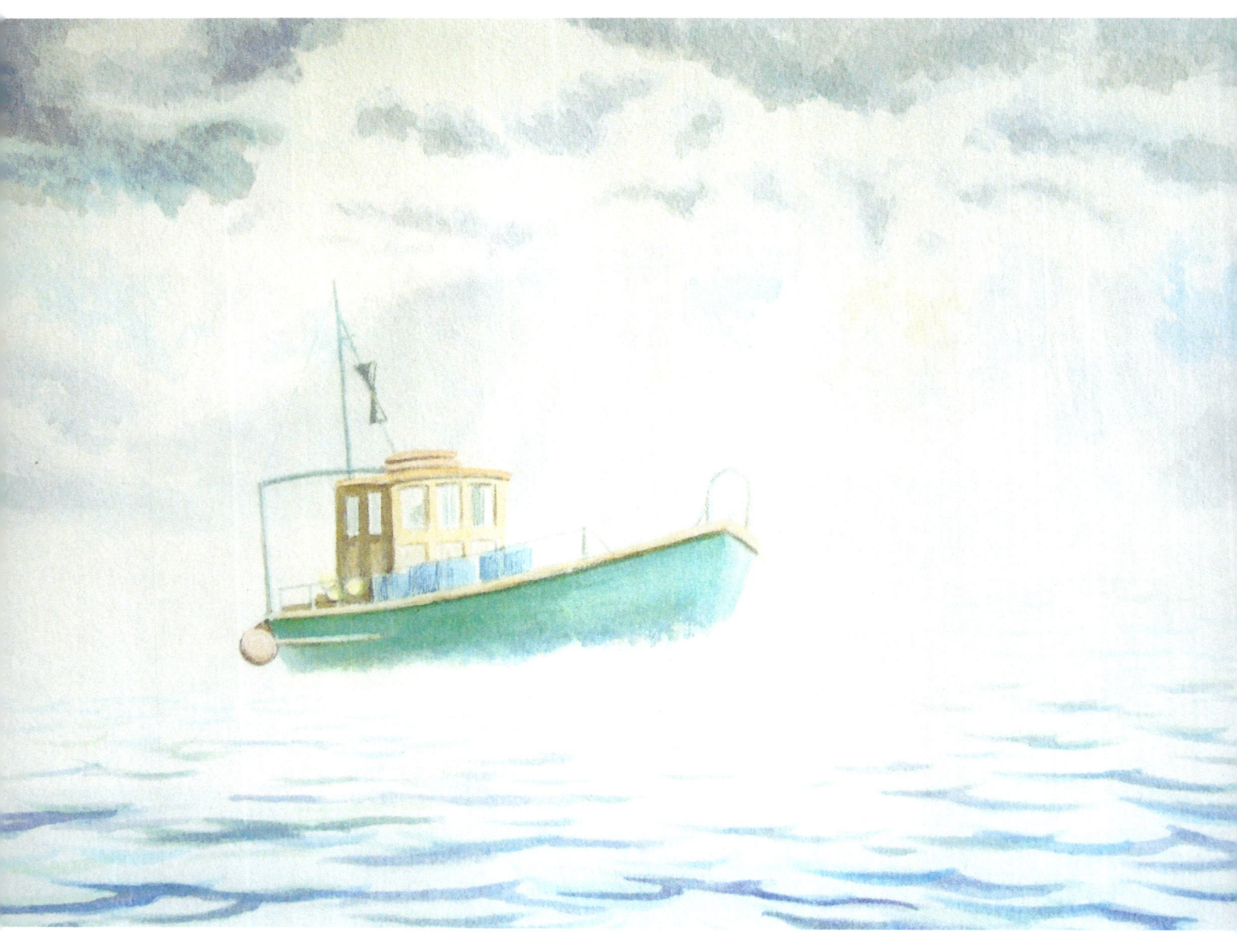

40)
'Fishing Boat - Working'
Media: Watercolour
Size: 340 mm * 540 mm

Mist and fog at sea can come from apparently nowhere and surround a boat in seconds. This fact makes for an interesting metaphor with regard to our daily lives.

The same applies to the picture maker. At times where we are heading for and what we hope to achieve is clear and easily focused upon. Then a dreaded mist can appear that engulfs everything around and obscures any reference as to where we are or are heading for. This is not a time for questioning or being afraid. If we are truly confident in the knowledge of where we are and our reason for being there, then it is a time to maybe slow down but to remain on course., and stay steady.

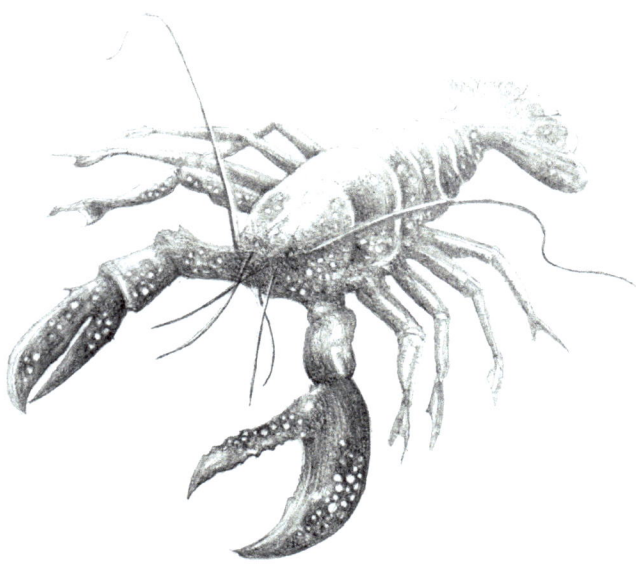

41) Page Right / Left
'Mr Lobster'
Media: Pencil
Size: 370 mm * 440 mm

42) Page Right / Right
'Tacking In The Mist'
Media: Watercolour
Size: 540 mm * 340 mm

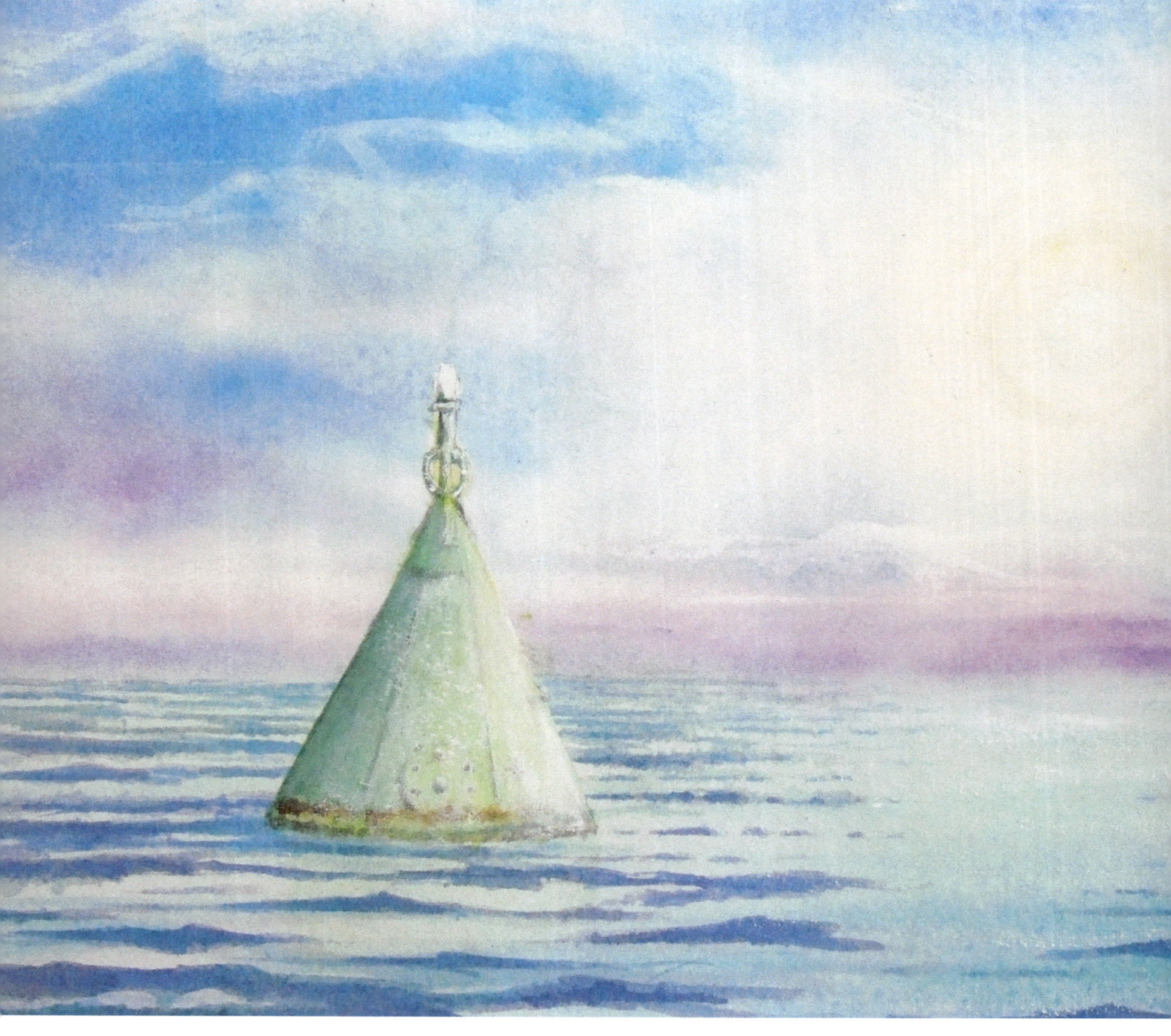

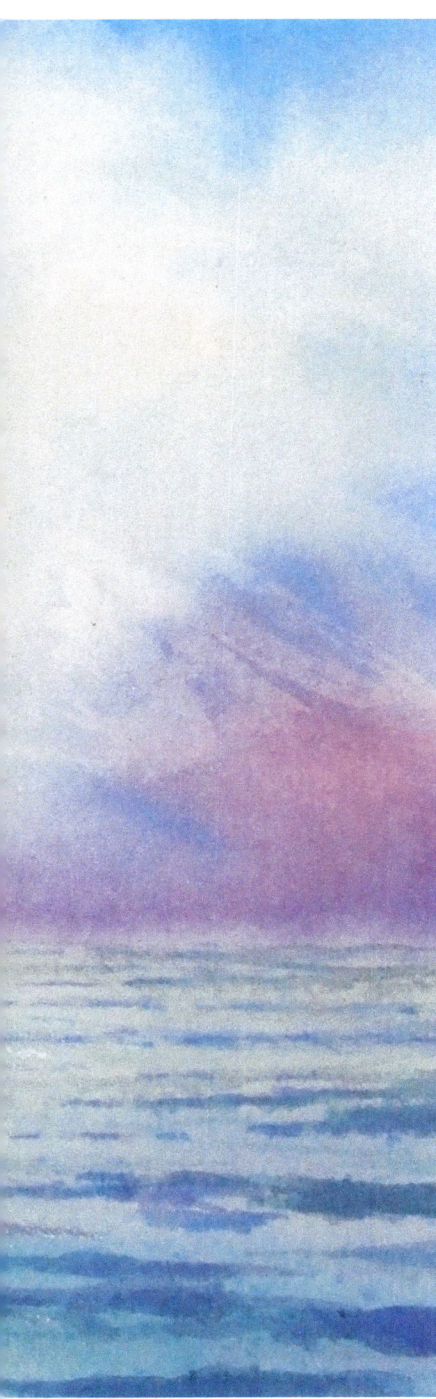
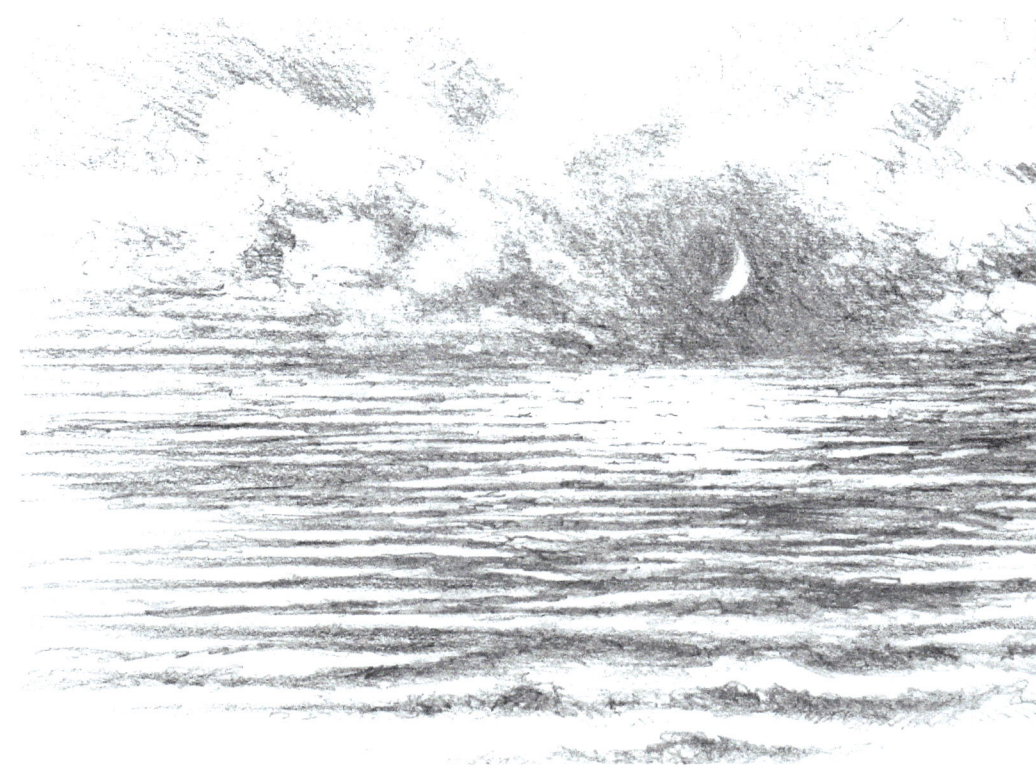

Easter Rock marks the approach to the Helford River. Although the Helford is now a special area of conservation in not too distant days it was vital waterway that supported Cornish industry.

Not just locally caught fish were landed along the river but ocean going vessels brought coal and timber and unloaded it here. Those same vessels departed the river with the fruits of local mines and quarries and delivered them around the world. How many boats before me have left these safe waters and ventured into the open ocean.

43) Page Left
'Easter Rock'
Media: Watercolour
Size: 340 mm * 540 mm

44) Page Right
'Waxing Moon'
Media: Pencil
Size: 370 mm * 440 mm

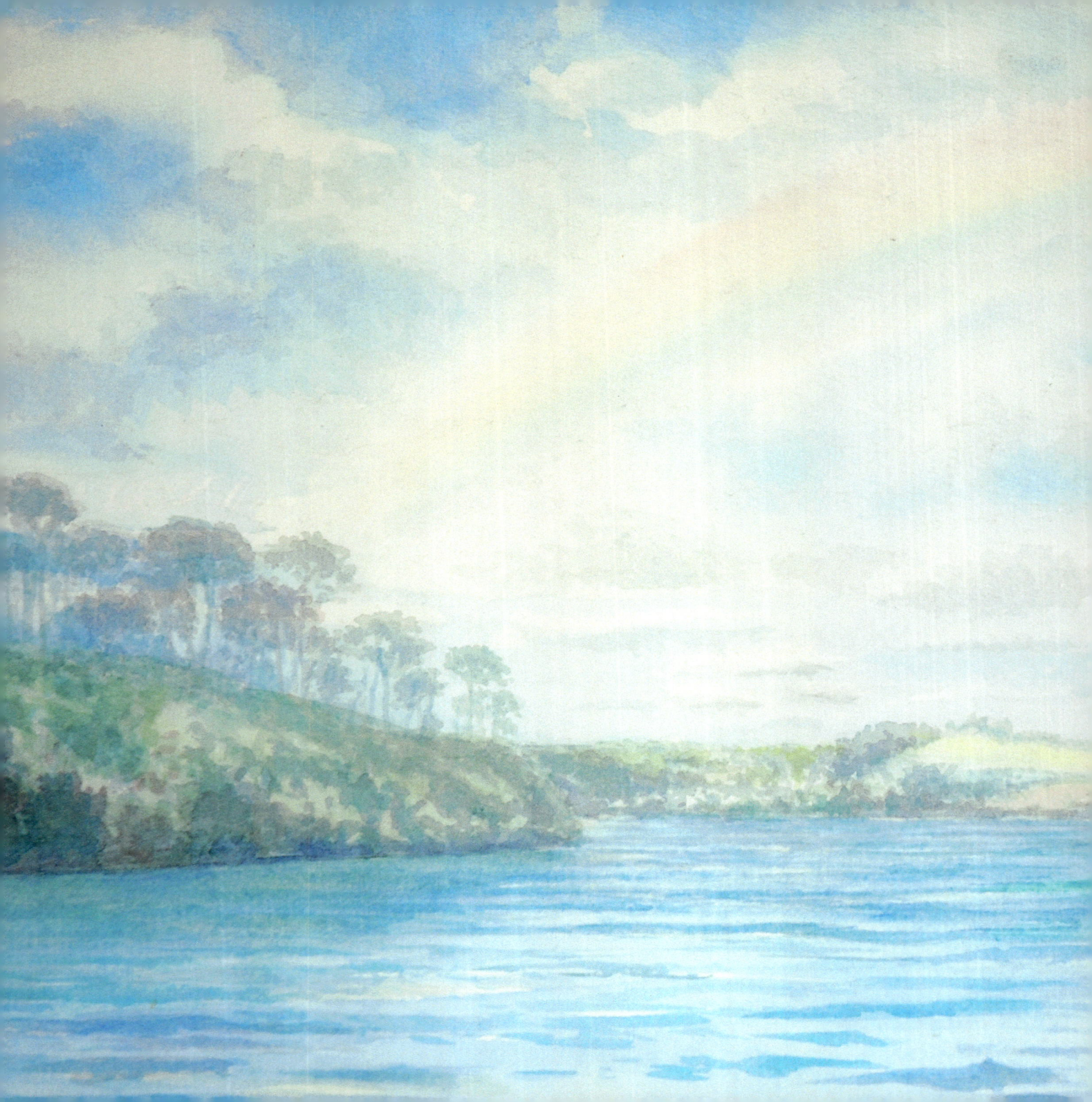

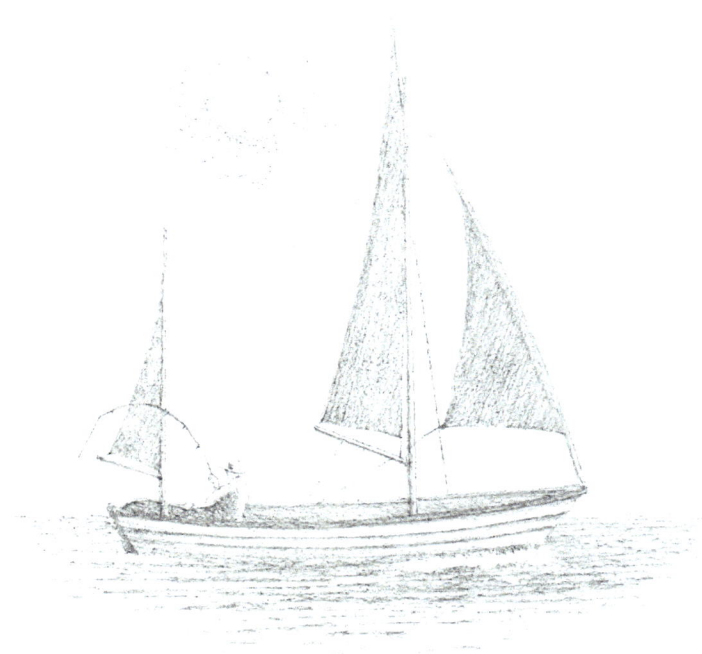

The picture maker may conveniently choose to believe that by the appearance of a rainbow above them that they have been blessed. In reality it is the location that is temporarily the recipient of one of nature's finest miracles.

To be lucky enough to witness such a wonder of nature's rare occurrences is indeed a privilege. To paint such a miraculous vision is an opportunity not to be missed. Yes! There is a heap of gold under each and every rainbow but the reward is how you see it, and what you choose to do with it.

45) Page Left
'Rainbow Over The Helford River'
Media: Watercolour
Size: 340 mm * 540 mm

46) Page Right
'Fishing From A Falmouth Bass Boat'
Media: Pencil
Size: 370 mm * 440 mm

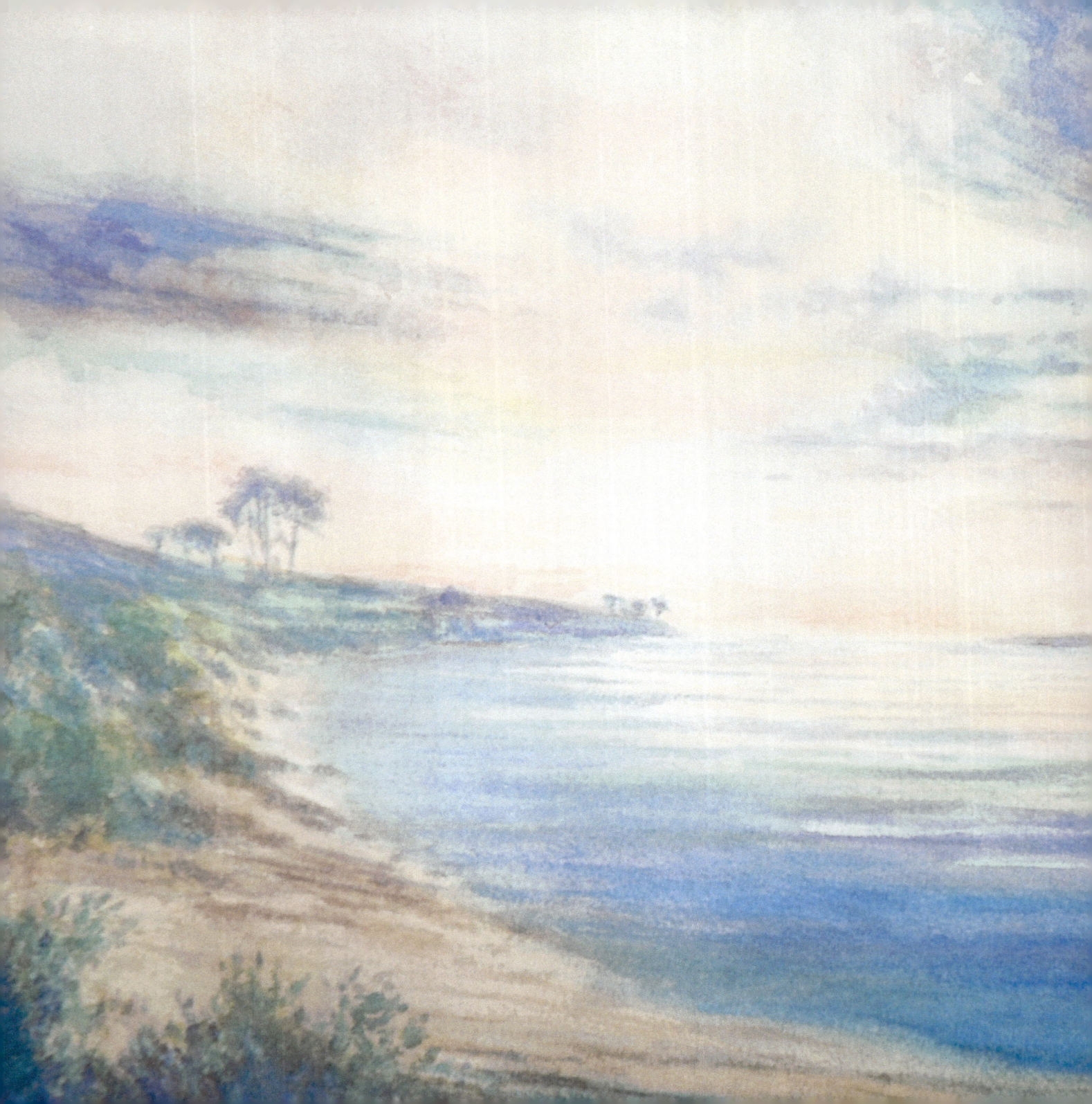

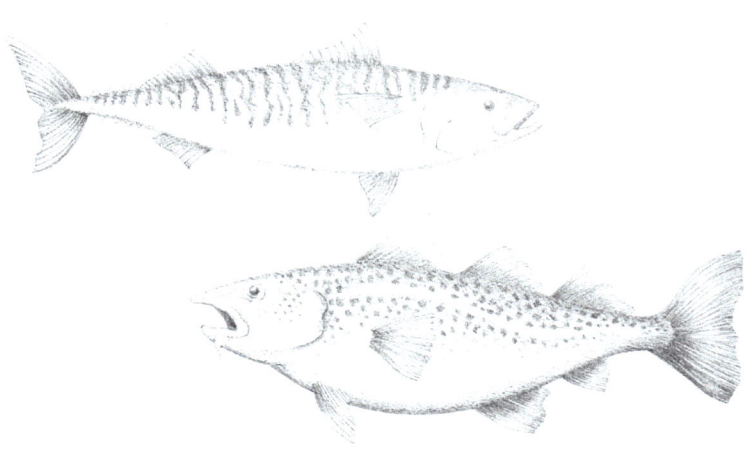

Close to the mouth of the Helford River and located on the north bank sits a small beach adjacent to the village of Durgan. This is a good spot to anchor and venture ashore. Snow and frost are a rarity here, spring comes early and winter late. Hence the variety of plant and wildlife that exists and resides along this coastline is not to be found further north.

Not only does Cornwall benefit from being kissed by the Gulf Stream the prevailing winds and air temperature bring about a micro-climate that results in a clement climate throughout most of the year.

47) Page Left
'Mouth Of The Helford River'
Media: Watercolour
Size: 340 mm * 540 mm

48) Page Right
'Mackrell & Cod'
Media: Pencil
Size: 370 mm * 440 mm

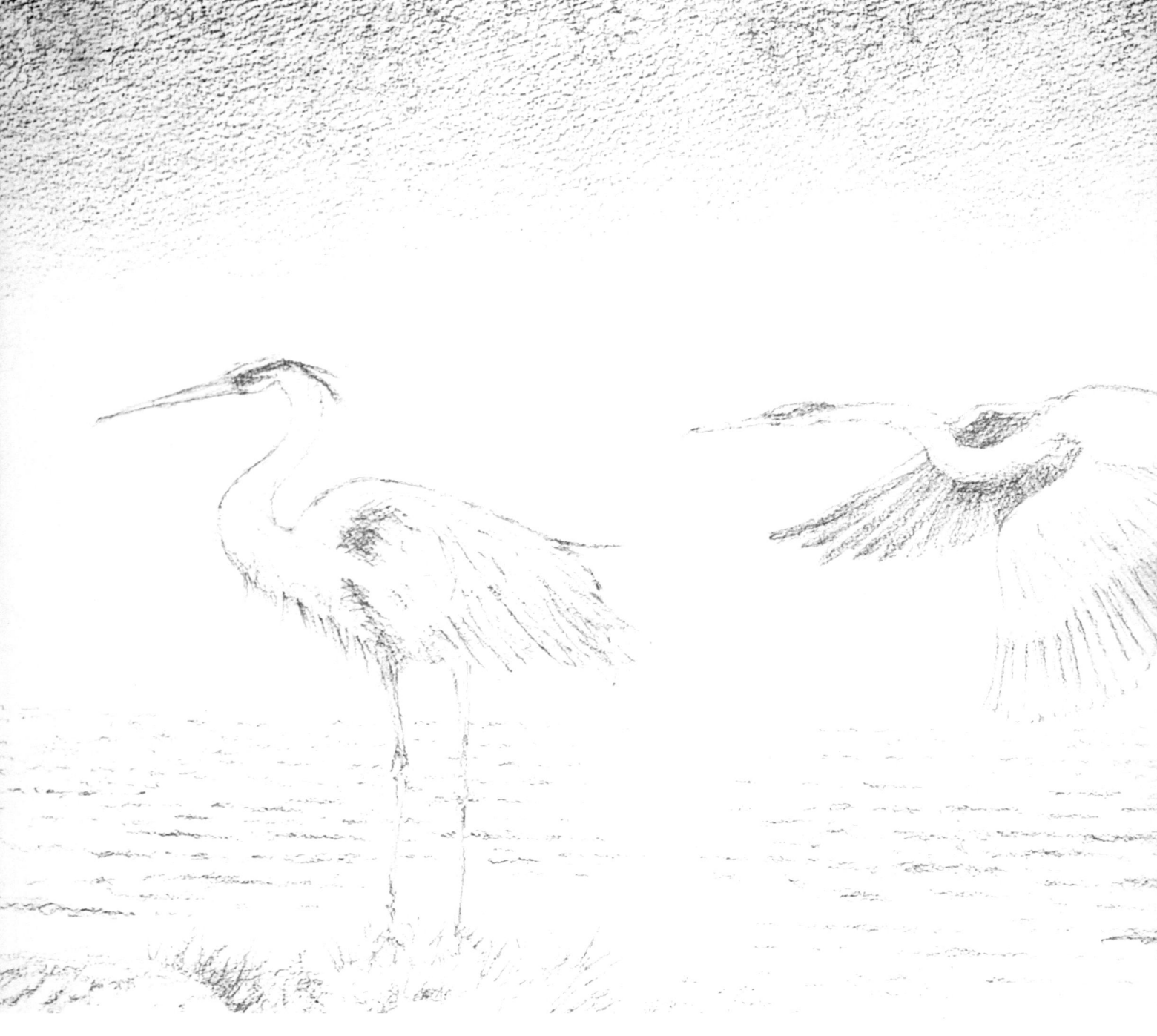

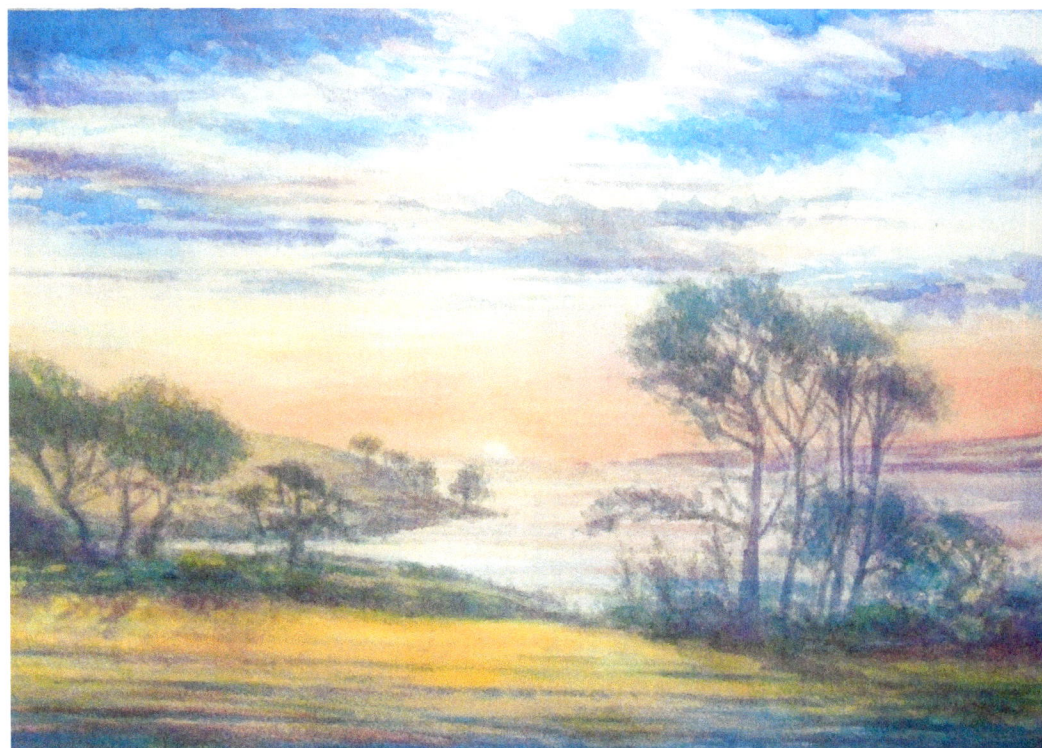

The solitude of exploring rivers and creeks while making pictures can at times be a lonely venture but the rewards are extraordinary. It is not just the wildlife encounters or the witnessing of the ever changing surroundings that nature presents that makes it so worthwhile, it is a deeply personal thing.

It is a thing that is of a preciousness that transcends monetary value. A thing that brings peace of mind, and a means by which to obtain a clearer perspective on one's own life.

49) Page Left
'Grey Herons'
Media: Pencil
Size: 340 mm * 440 mm

50) Page Right
'Above Durgan'
Media: Watercolour
Size: 340 mm * 540 mm

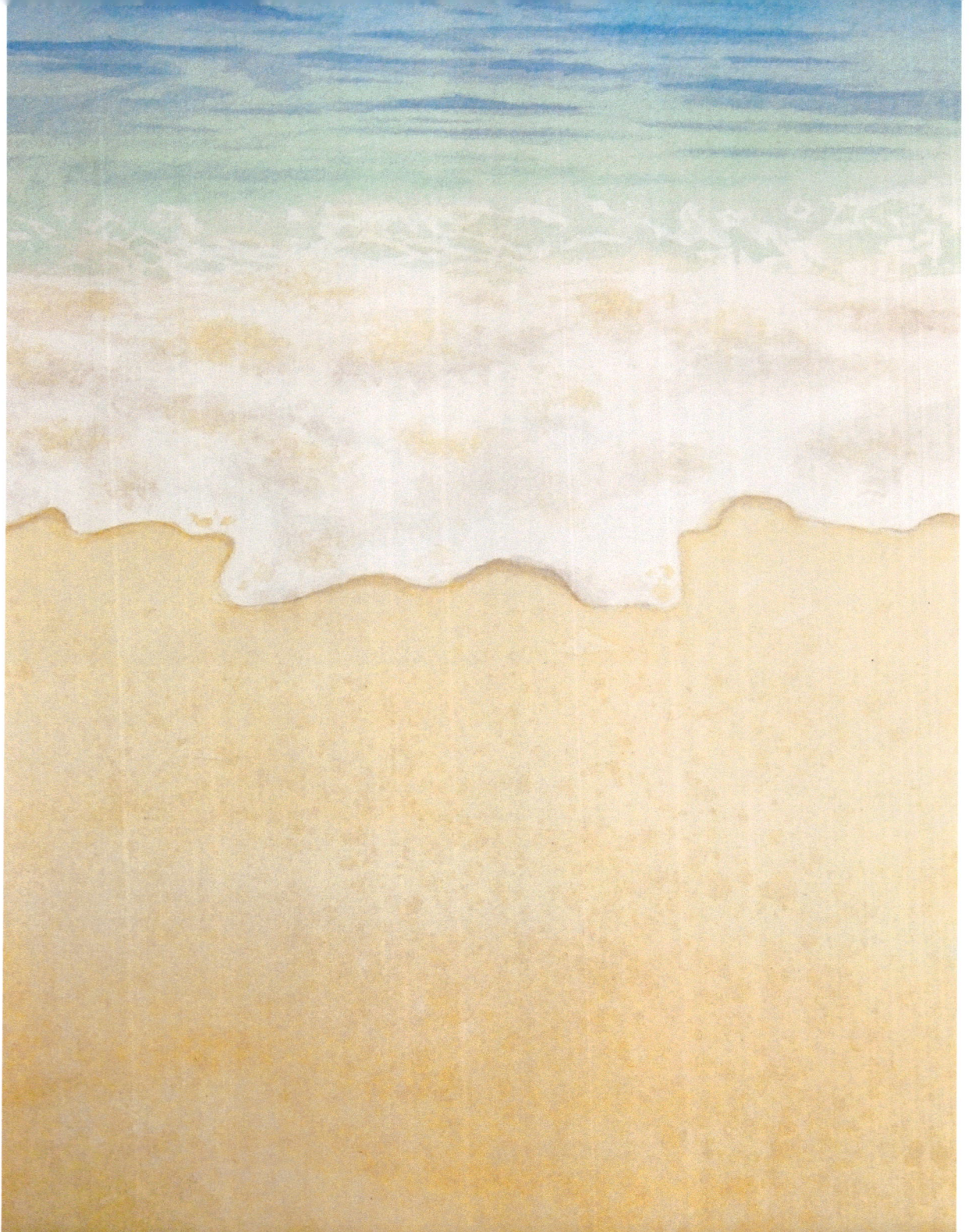

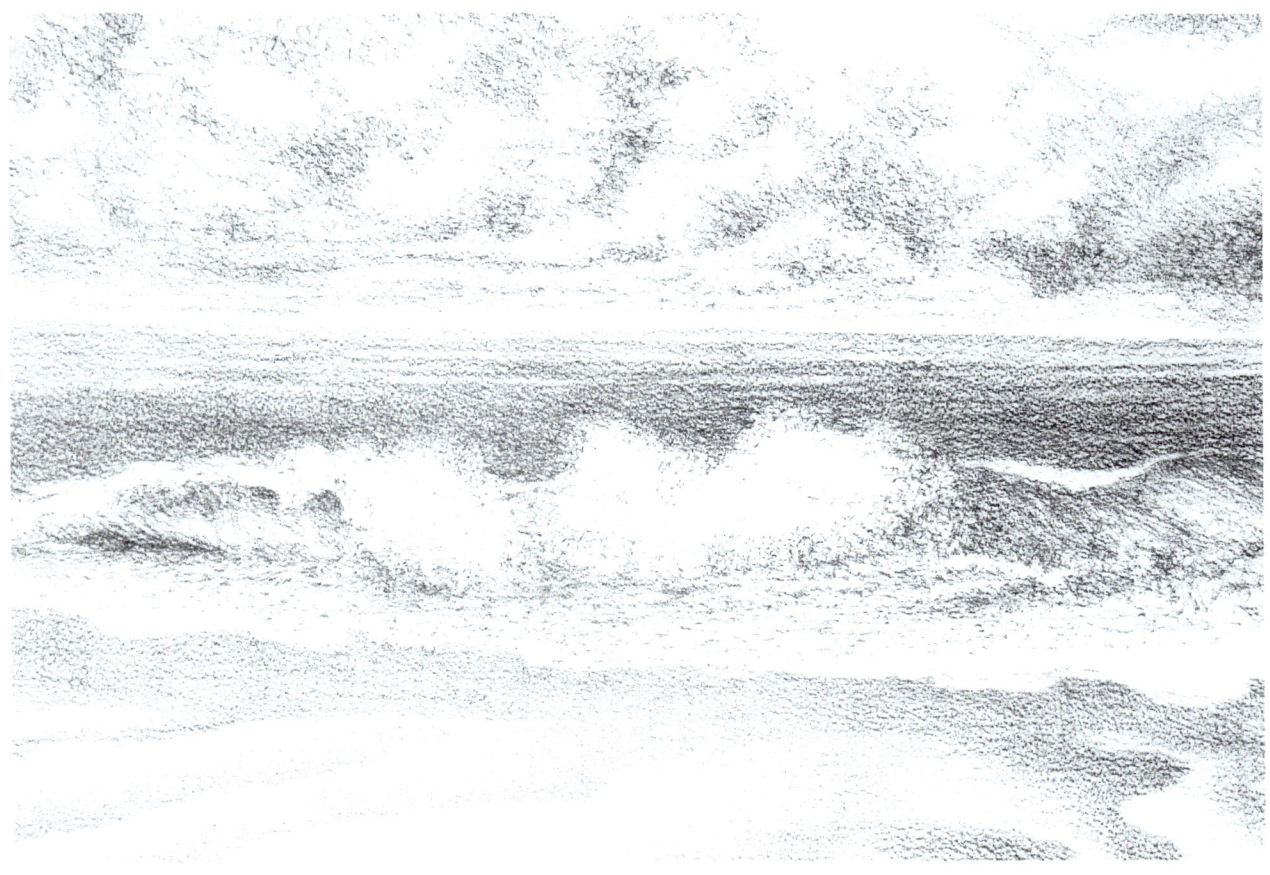

I have been attempting to draw and paint waves since I was a small boy. As an old man I think I may just be getting the hang of it. The trick is not to try to make the picture look like a wave. It is to create the illusion that the viewer feels that they could quite easily step into it.

I guess waves are not unlike the days of our lives. They come and go, they are sometimes gentle, and at other times they bash us around a little. This is not to be complained about, for when there are no more waves there will be no more 'You'.

51) Page Left
'The Ocean's Doorstep'
Media: Watercolour
Size: 540 mm * 360 mm

52) Page Right
'Rolling Waves On Beach'
Media: Pencil
Size: 340 mm * 540 mm

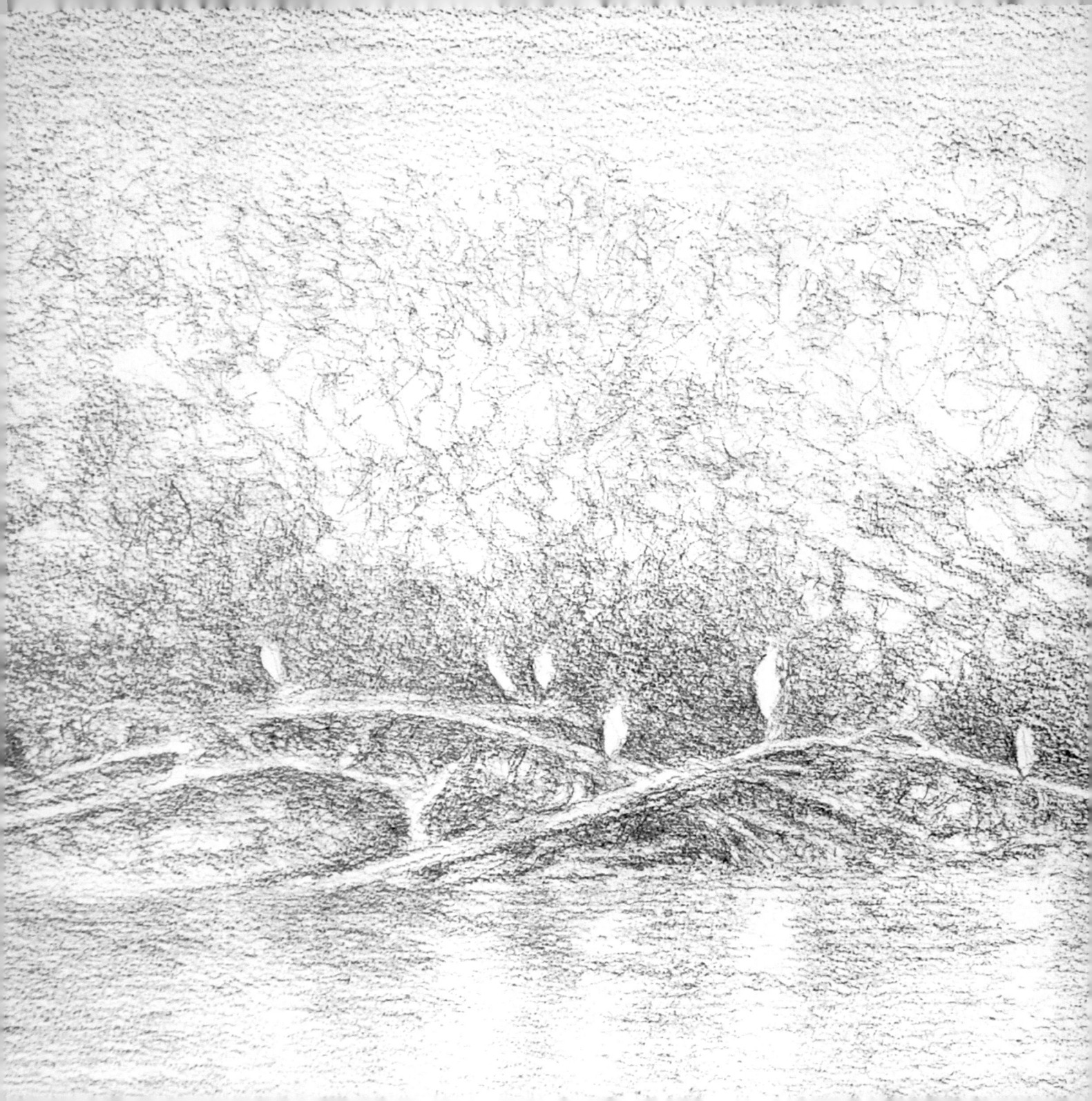

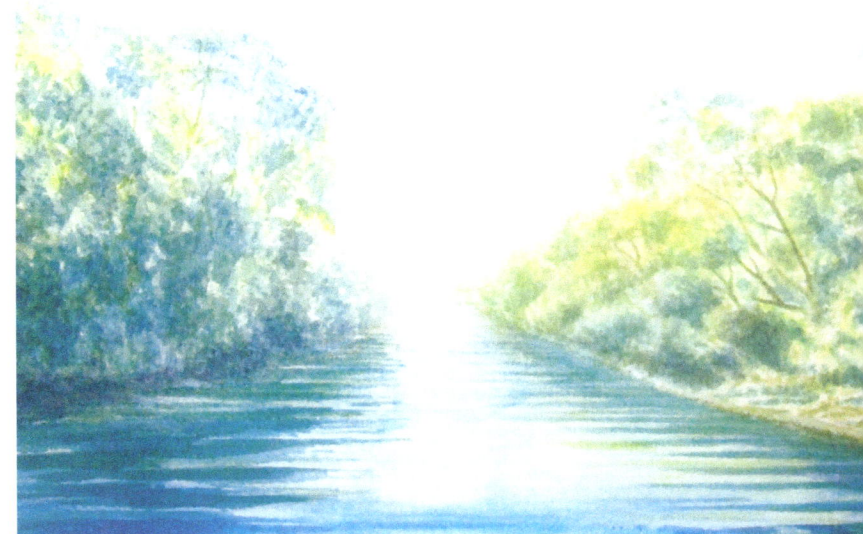

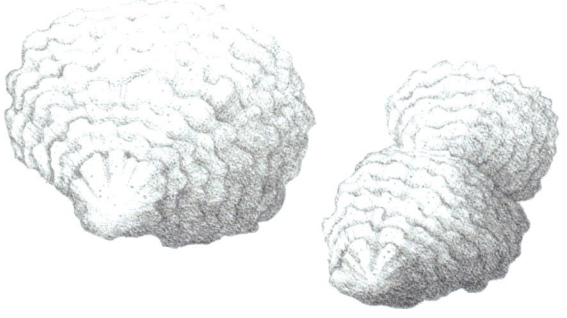

Oyster-fisherman harvest this river and many egrets nest alongside the banks. During the summer months the Helford is a popular destination for holidaymakers. However, the river hides many locations and creeks that can only be reached and explored while being afloat.

53) Page Left
'Egrets Nesting Along The Riverbank'
Media: Pencil
Size: 340 mm * 540 mm

54) Page Right / Top
'Another Bend In The River'
Media: Watercolour
Size: 340 mm * 540 mm

55) Page Right / Bottom
'Oysters'
Media: Pencil
Size: 370 mm * 440 mm

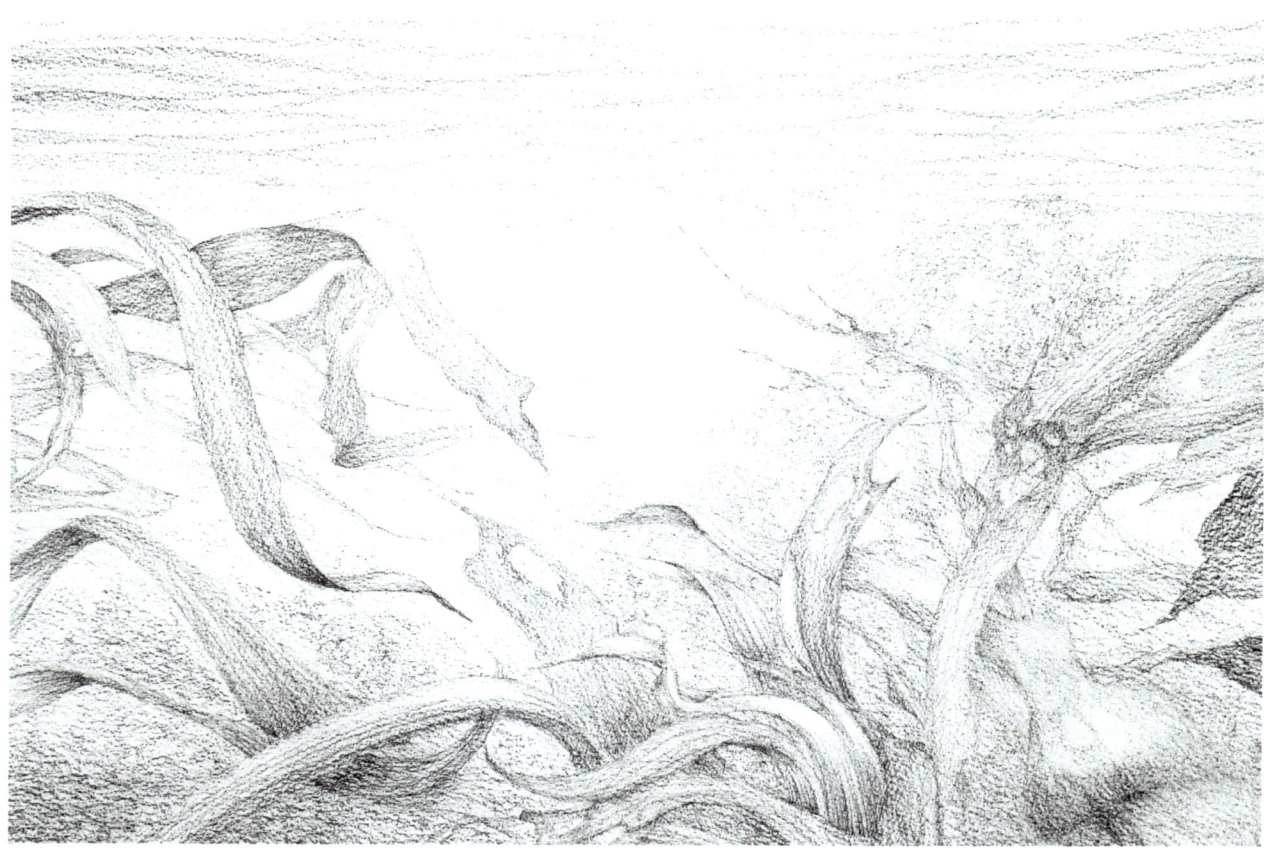

As with all of the locations illustrated in this book, the Helford River offers great fishing opportunities. Being afloat with a fishing line trailing astern is a fine way of passing the hours away but from the shady banks that line the river and creeks can be found equally as rewarding spots for the fisherman to exercise his skill and cunning,

Only the fisherman understands the thrill of that moment when the bait it taken. That moment when what is hooked remains as yet unidentified.

56) Page Left
'The Hunted Hiding In The Kelp'
Media: Pencil
Size: 340 mm * 540 mm

57) Page Right
'Fish On'
Media: Watercolour
Size: 540 mm * 340 mm

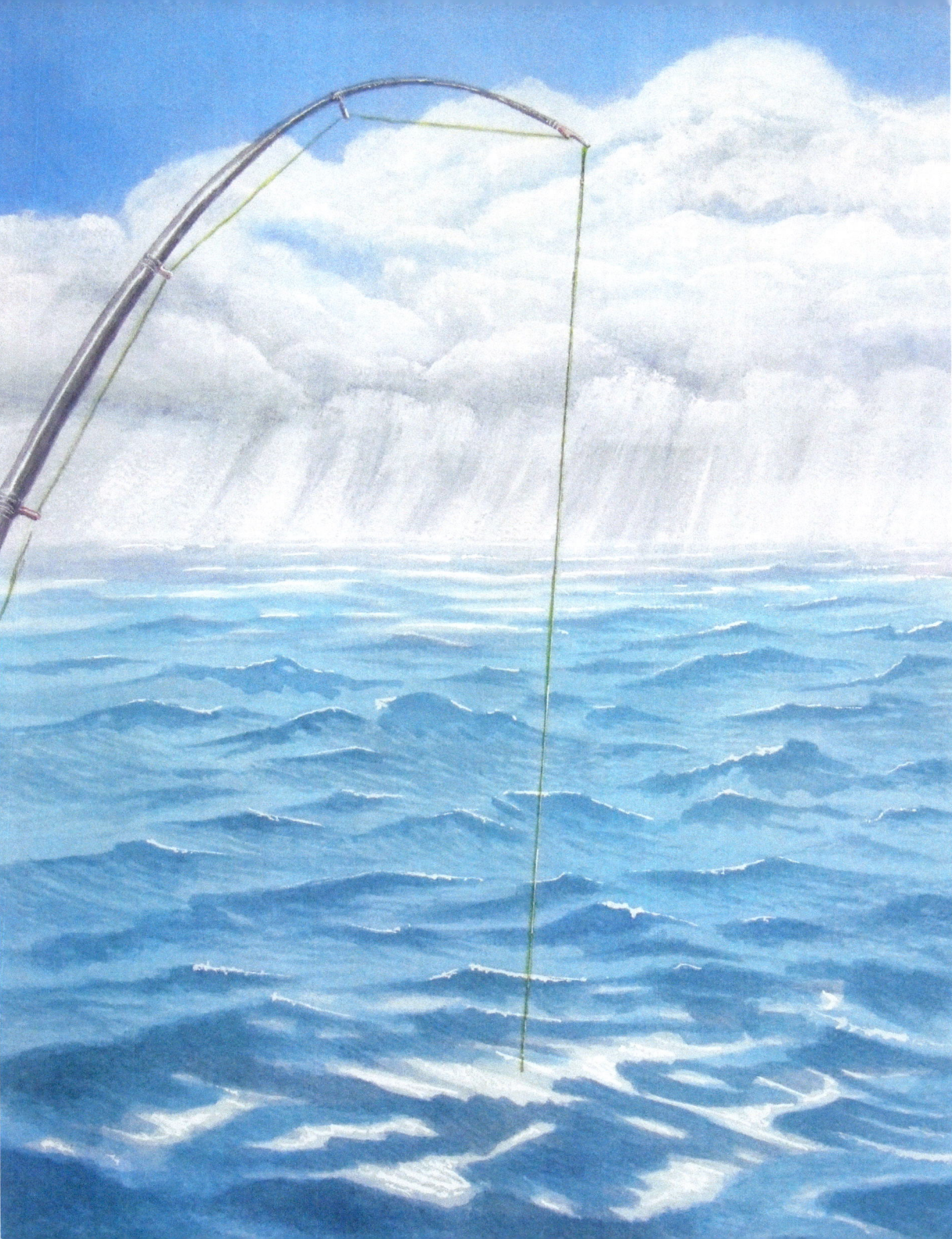

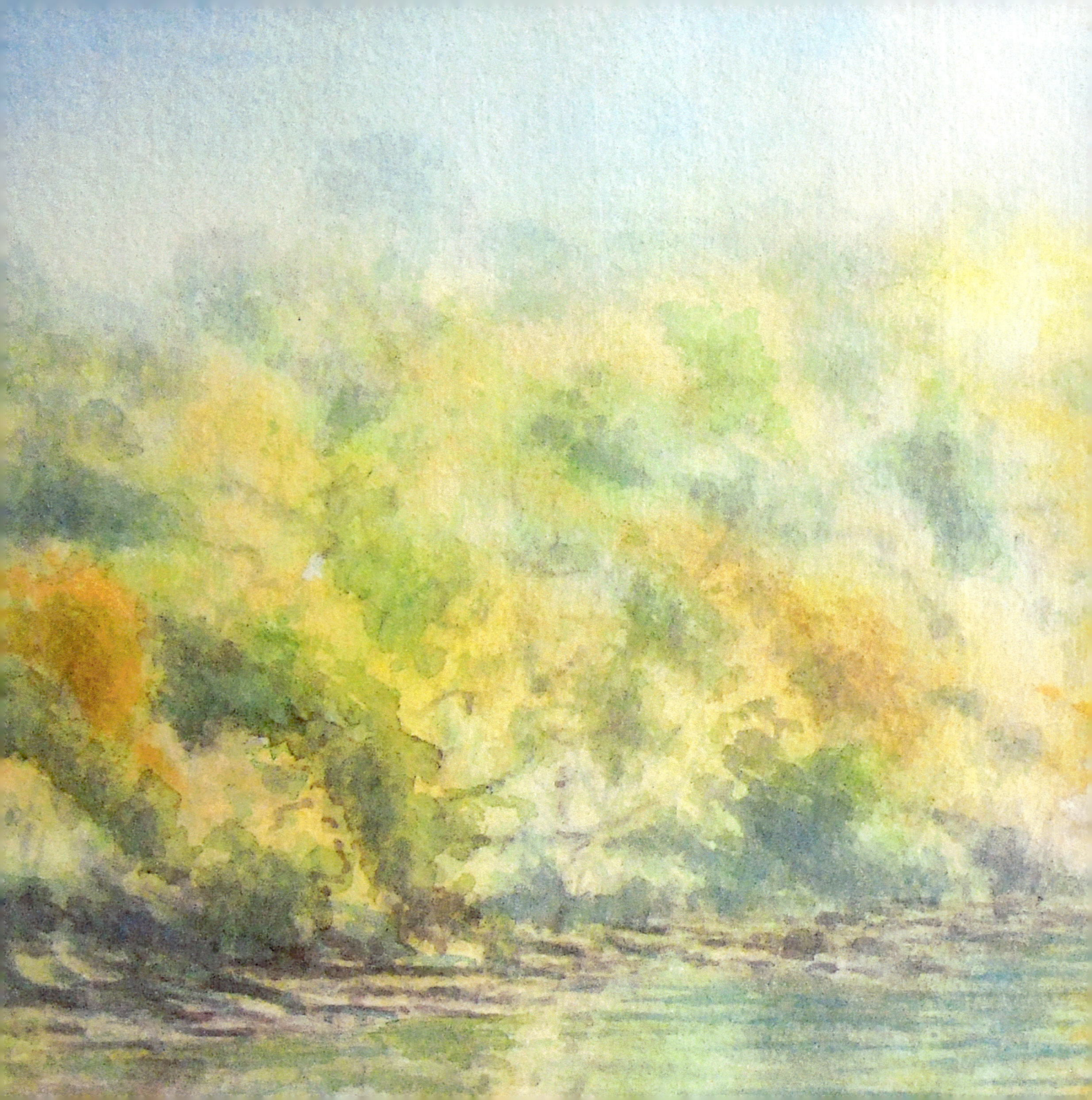

As summer draws towards an inevitable end the folia that lines the banks of the rivers and creeks begins to change from green and yellow to a matrix of gold and copper tones. It is a time of great beauty, a signal for the coming time of rest and hibernation.

Frenchman's Creek was made famous by Daphne du Maurier in her historical novel that she wrote in 1941. Her book is set during the reign of Charles II, it tells the story of a love affair between an impulsive English lady, Dona, Lady St. Columb, and a French pirate named Jean-Benoit Aubéry. My mother loved this book and told me about it when I was a small boy. I wanted to visit this place for many years and now I have.

58)
'Frenchman's Creek'
Media: Watercolour
Size: 340 mm * 540mm

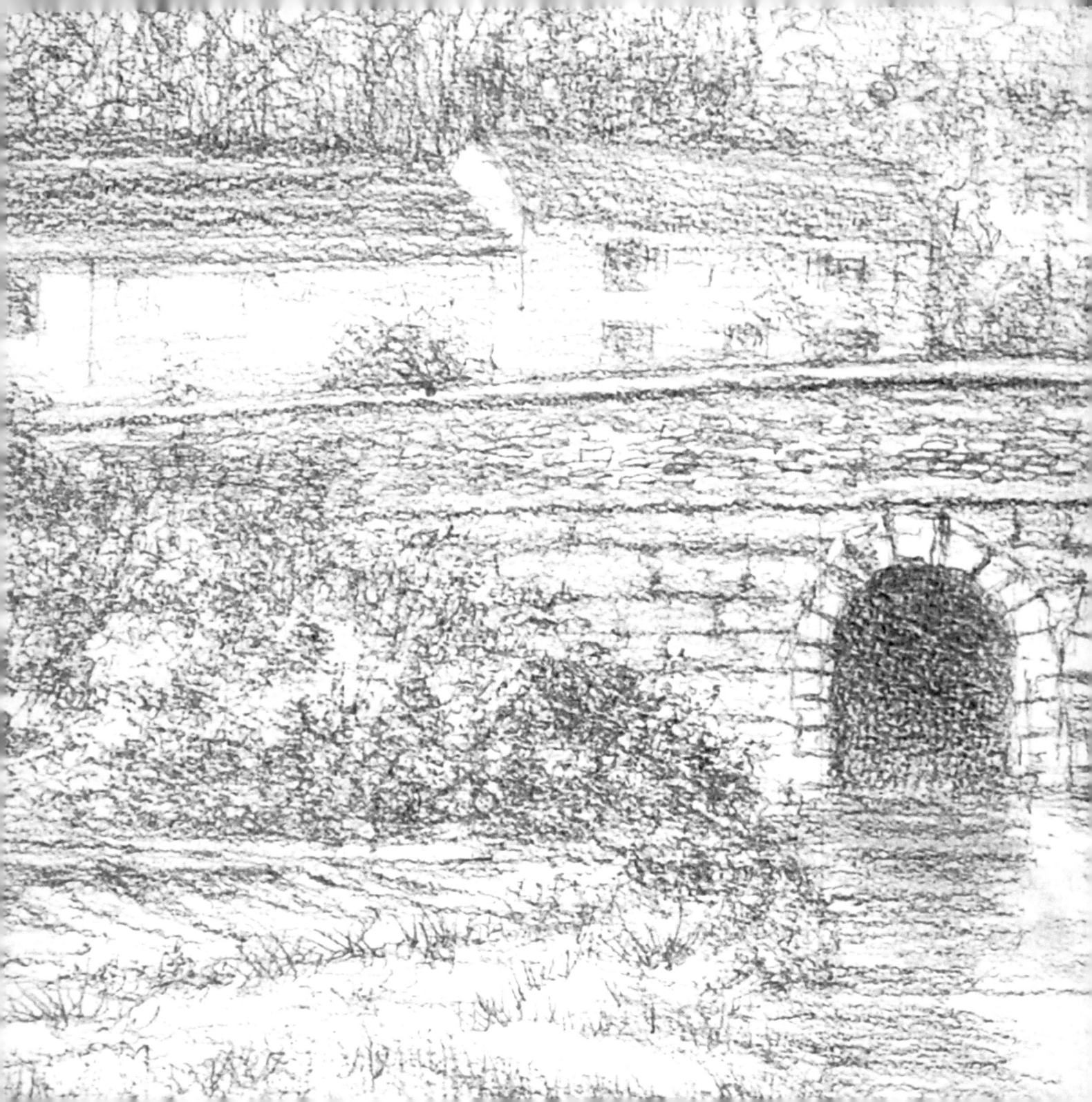

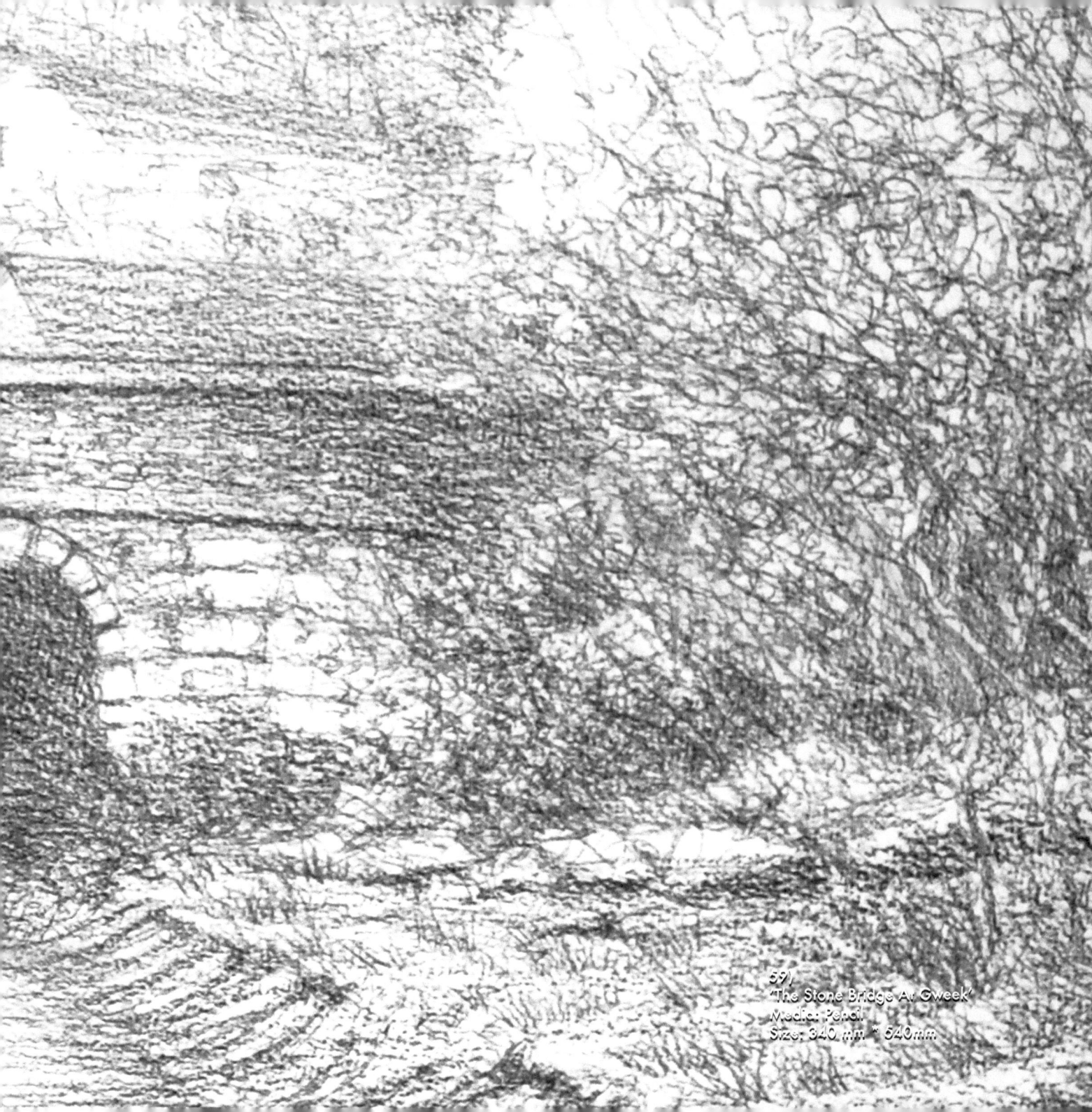

59)
'The Stone Bridge At Gweek'
Medium: Pencil
Size: 340 mm * 540mm

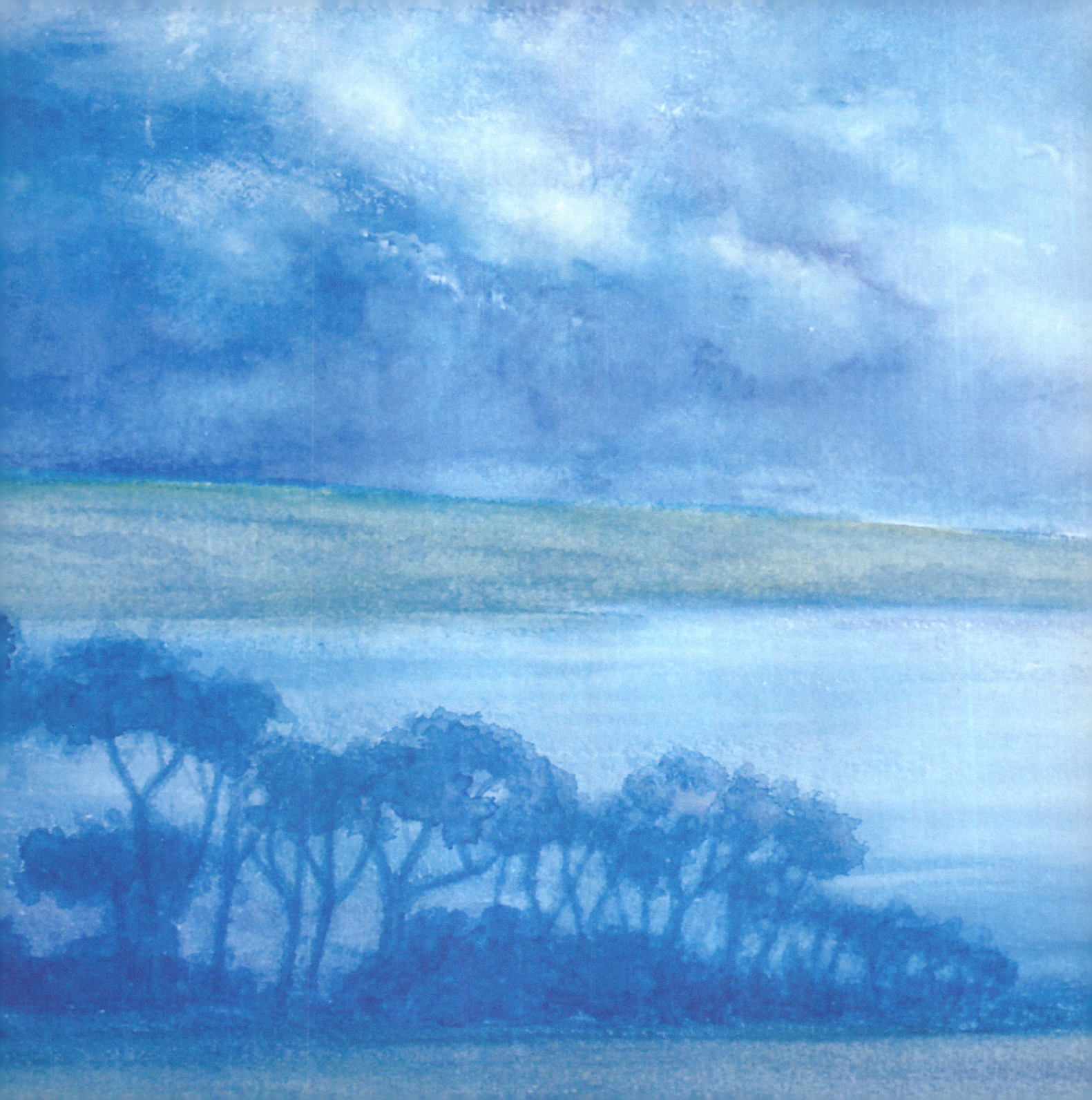

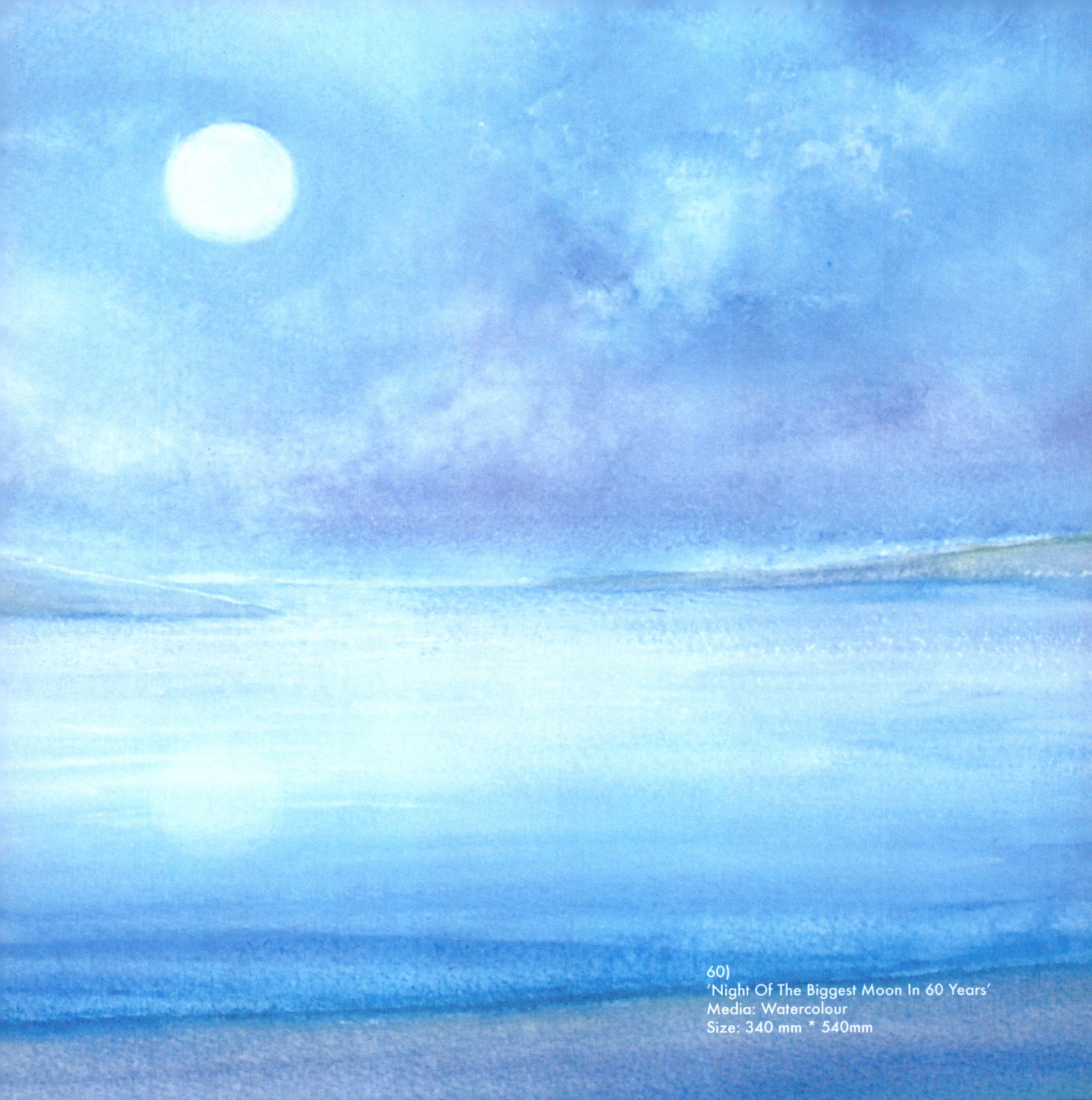

60)
'Night Of The Biggest Moon In 60 Years'
Media: Watercolour
Size: 340 mm * 540mm

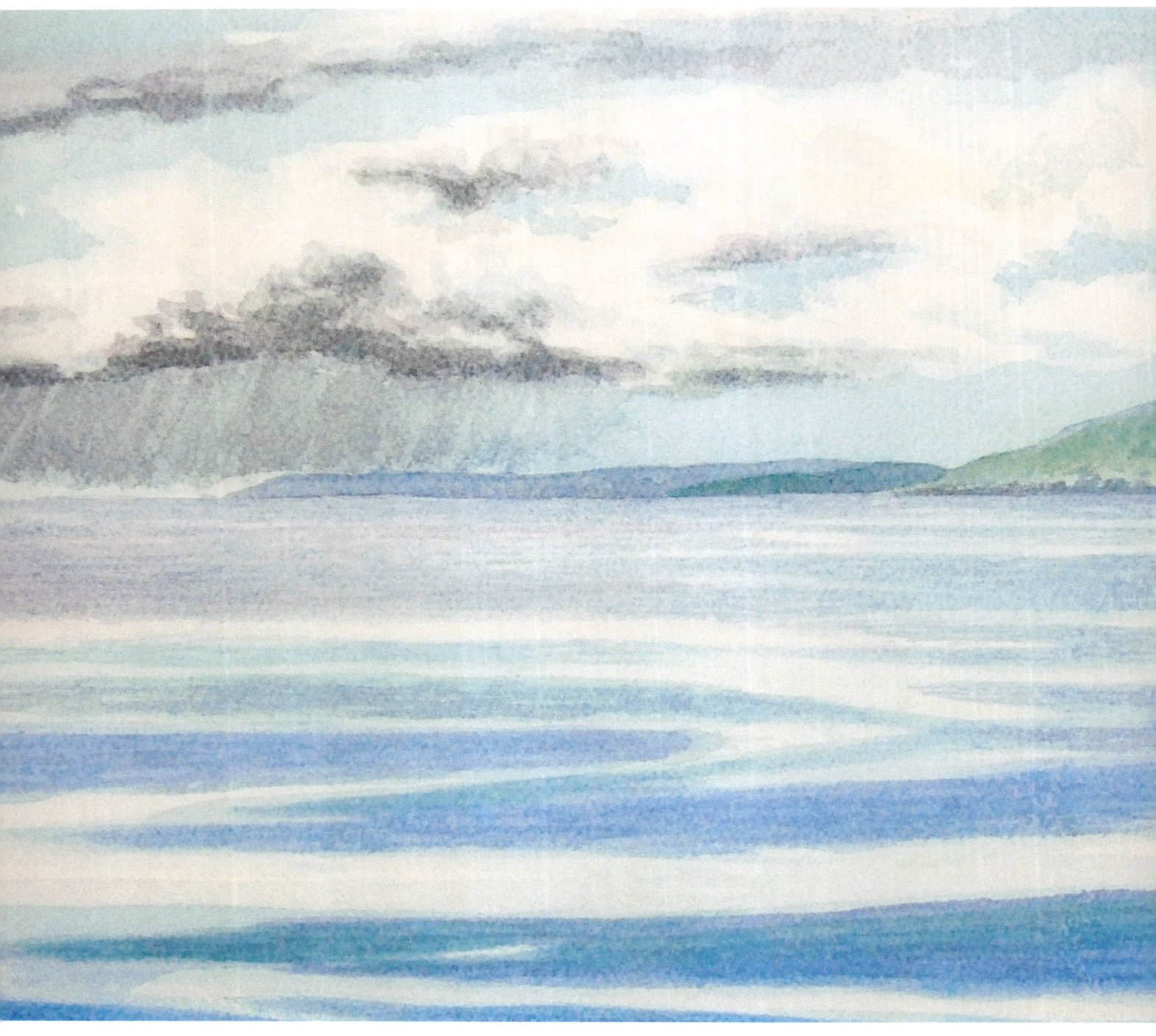

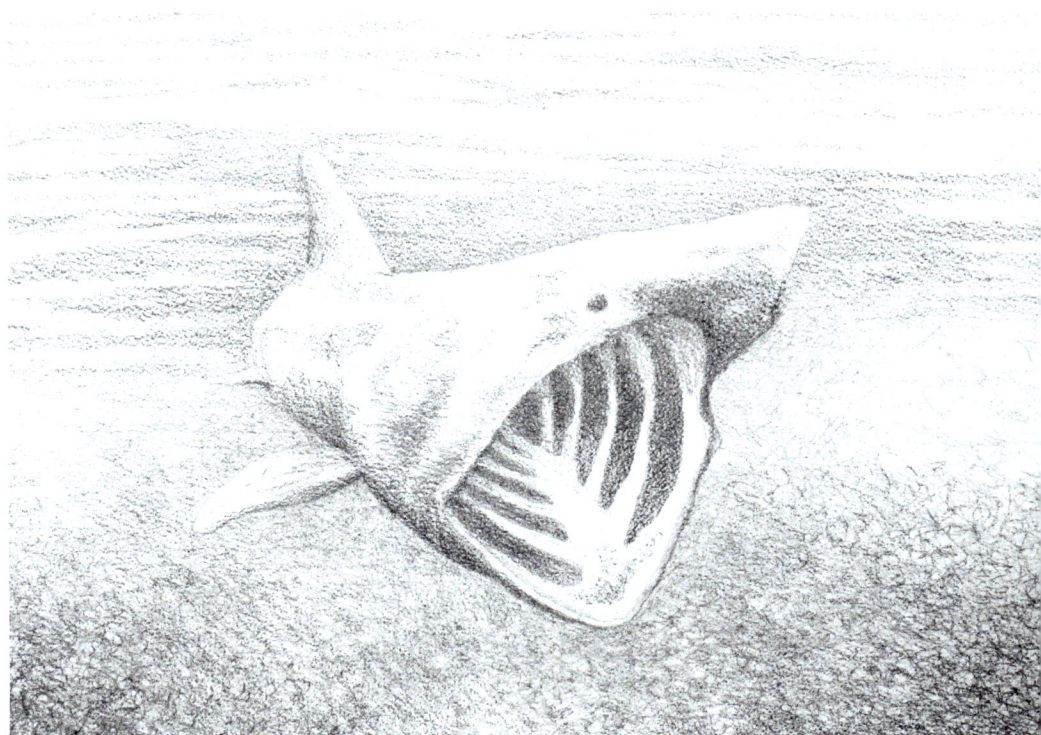

Painting of the surface of the water and the skies above is an endless challenge. So many times I have looked at these ever-changing facets of nature and thought that if they were on paper or canvas that the result would be entirely artificial and unconvincing. One of the most difficult scenes to replicate must be when the weather is about to change. Another is when the ocean is near to being flat calm and a gentle breeze draws random patterns upon the surface.

The knowing that a host of marine life is always present but out of sight sets the imagination going and is another opportunity for the picture maker.

61) Page Left
'Weather Bank'
Media: Watercolour
Size: 340 mm * 540 mm

62) Page Right
'Basking Shark'
Media: Pencil
Size: 340 mm * 540 mm

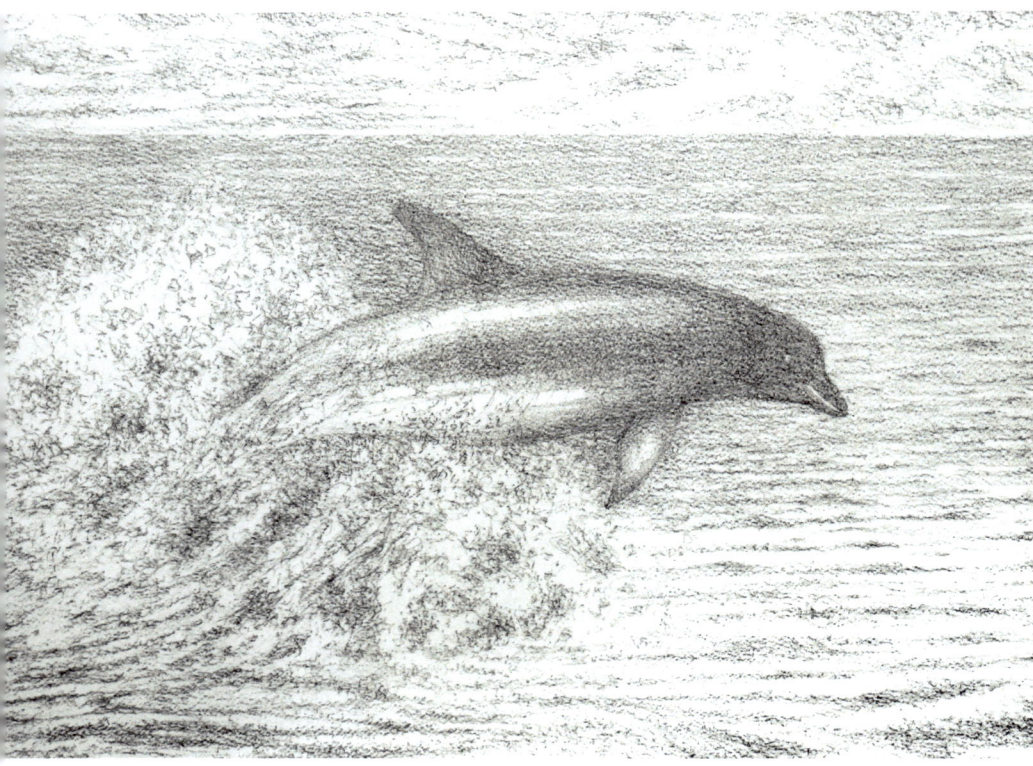

On occasion the marine picture maker is blessed and the ocean presents one of it's inhabitants in full view and at close range. Or by just sitting on a rock at the water's edge a never ending and ever changing kaleidoscope of colour and movement can be witnessed.

These are some of the wonders of making pictures from nature that can be experienced at first hand.

63) Page Left
'Bottle Nose Dolphin'
Media: Pencil
Size: 340 mm * 540 mm

64) Page Right
'Smashing Wave'
Media: Watercolour
Size: 340 mm * 540 mm

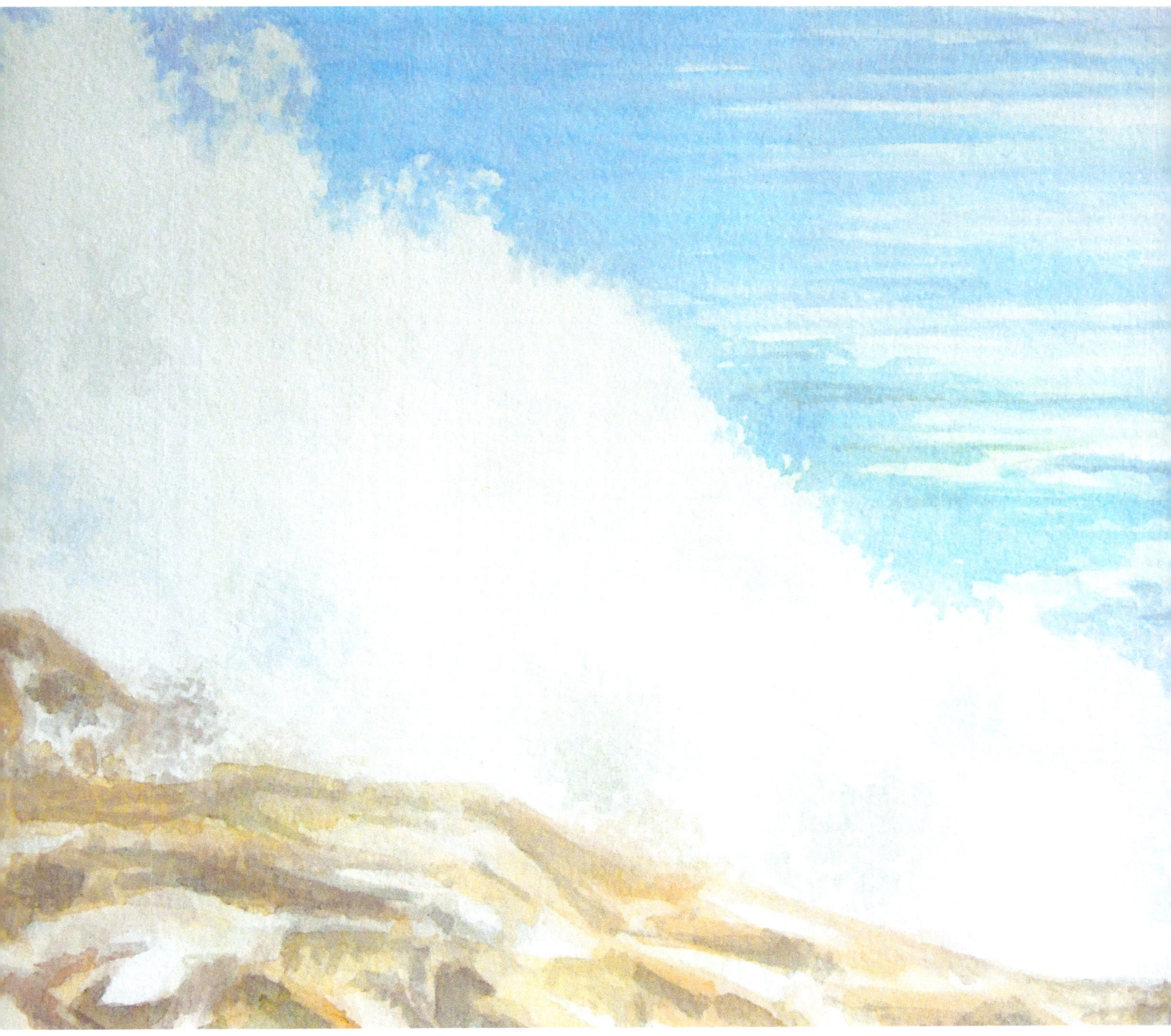

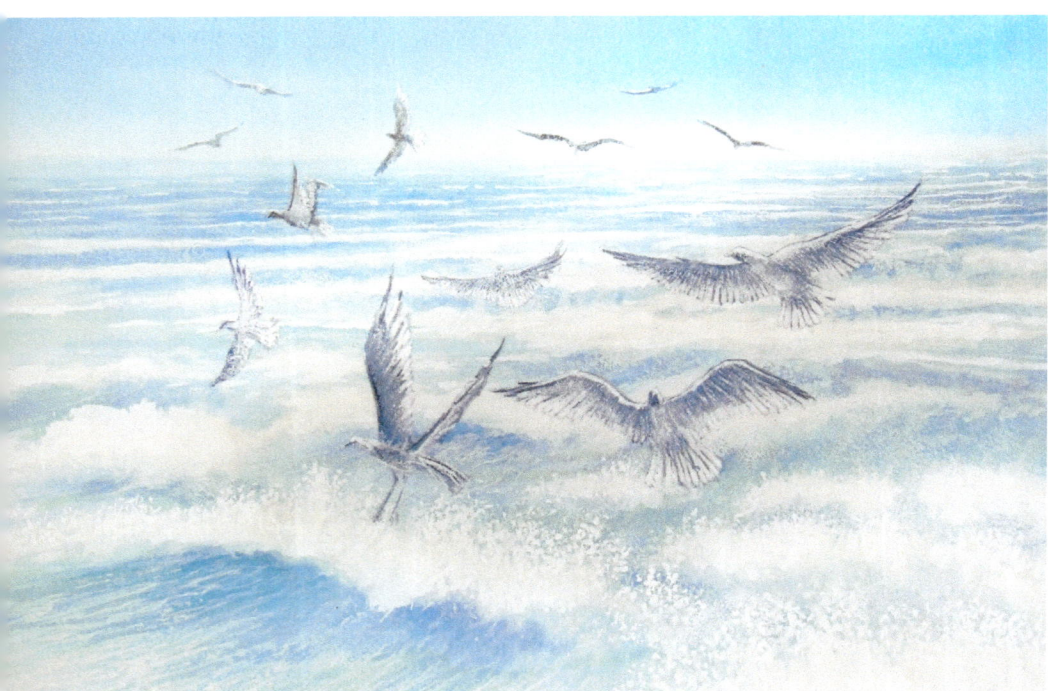

If it were not for the stars that fill our night skies and early man's knowledge of their changing positions our history would be very different. It was by these that we learned how to navigate the oceans and explore far off lands. It was on many of those distant continents and islands that westerner's discovered minerals, dyes, and methods of harnessing their bright and vibrant colours that artist's were able to create pictures that are close to the rich and varied colour pallet that nature presents to us.

Without our ability to perceive colour and replicate or manipulate it, this world of ours would be a drab place indeed.

65) Page Left
'Following Gulls'
Media: Watercolour
Size: 340 mm * 540 mm

66) Page Right
'Sea-mist & Stars'
Media: Watercolour
Size: 340 mm * 540 mm

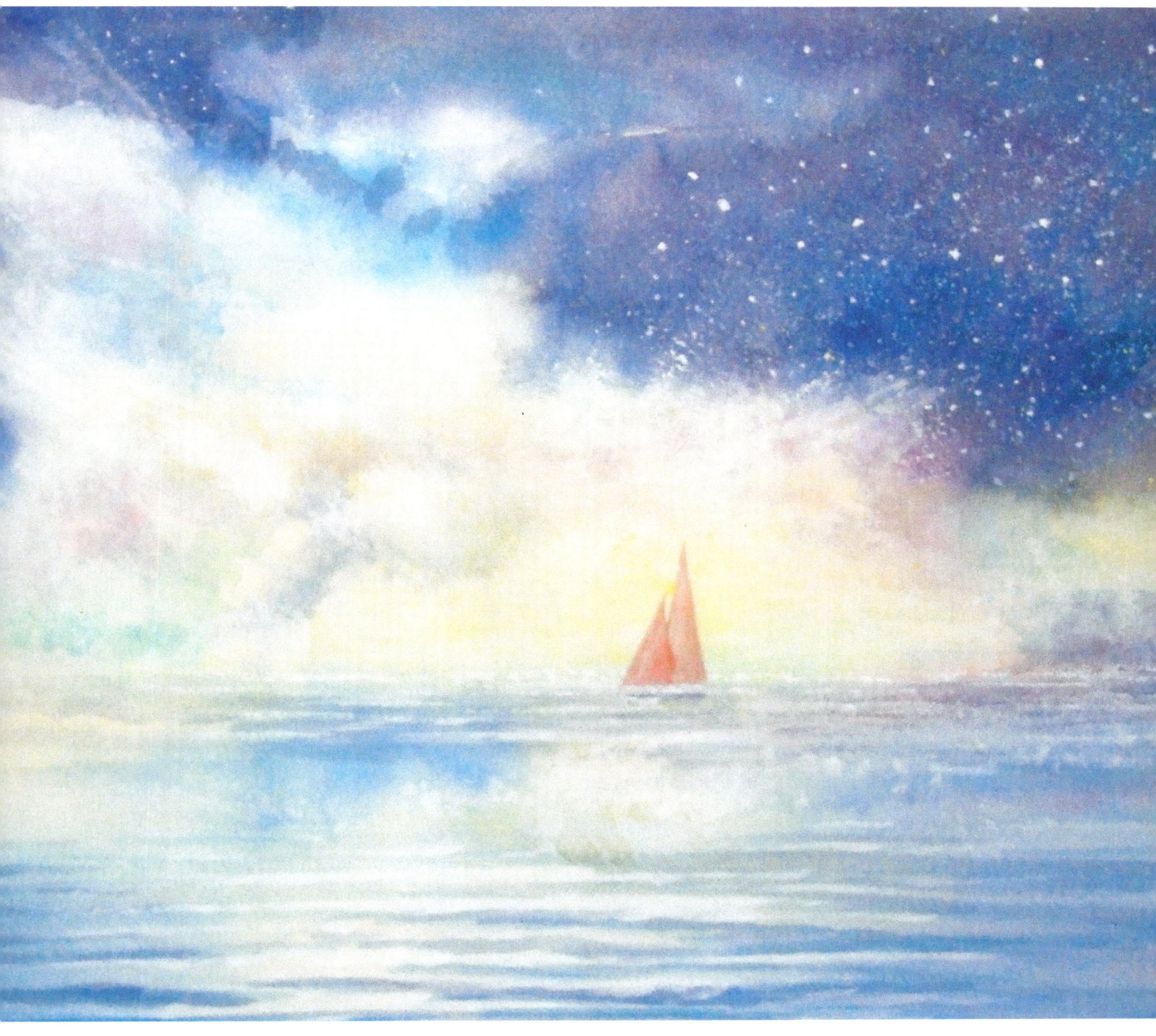

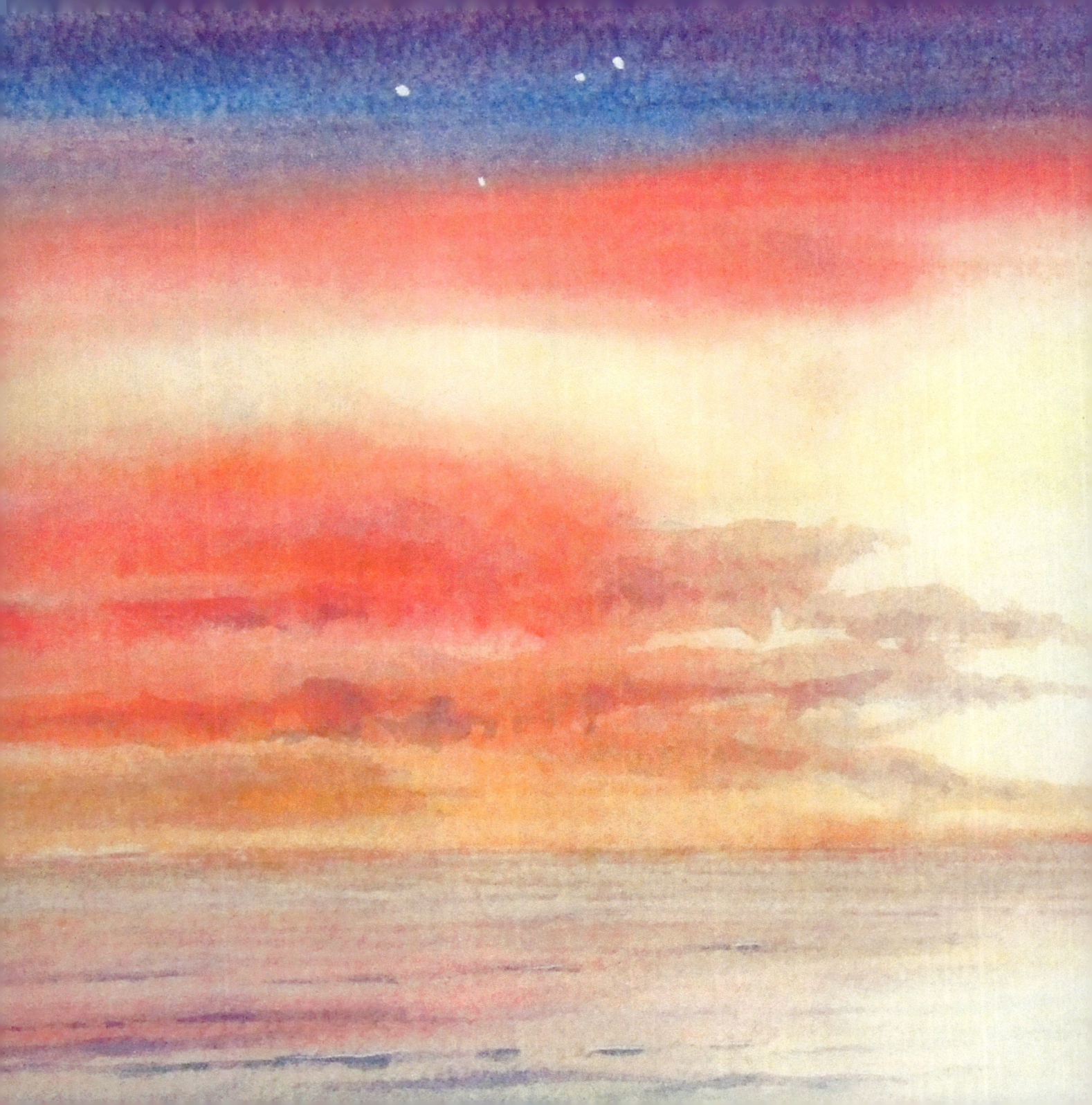

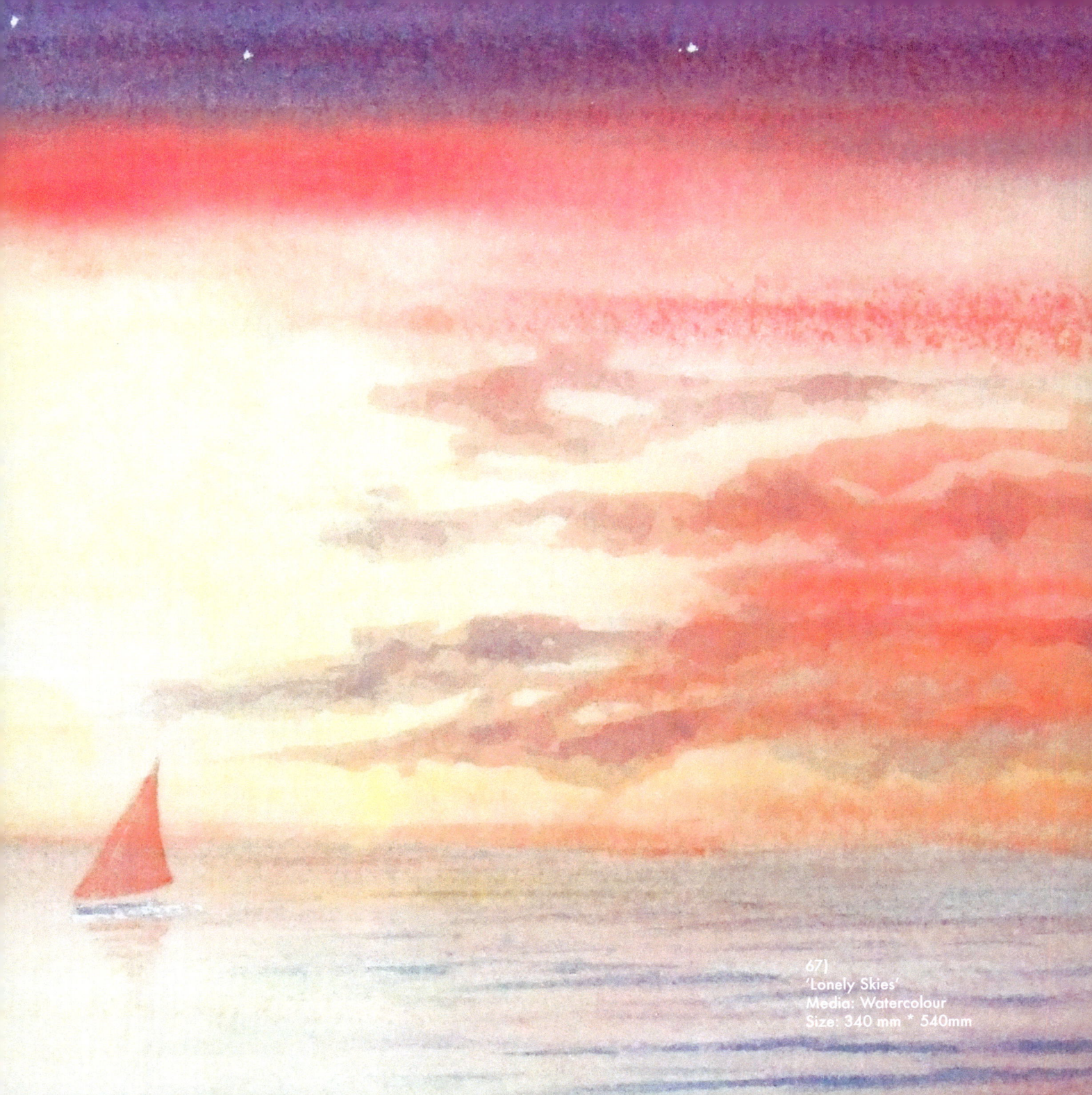

67)
'Lonely Skies'
Media: Watercolour
Size: 340 mm * 540mm

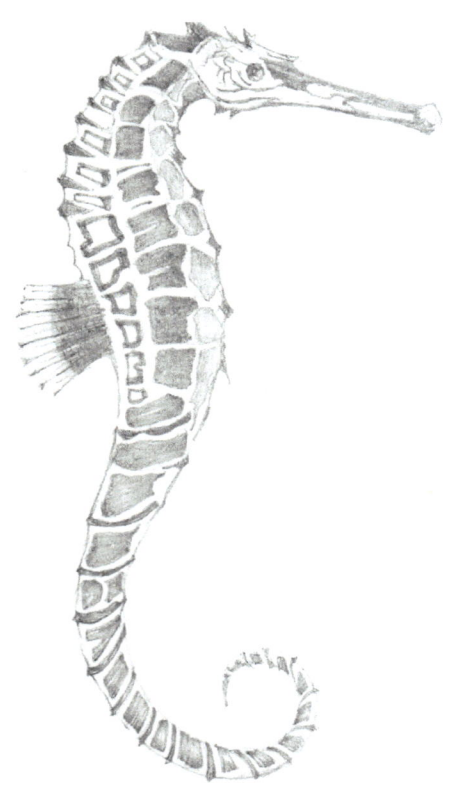

The wonders of nature are seemingly endless. The strange and sometimes weird creatures that we share this planet of ours with we sometimes find to be bewildering.

We don't have to be scientists, ornithologists, or botanists to study such life forms, merely a pencil and some paper is all that is needed for gaining an insight into nature's secrets. Even the occasional violence of the elements can be inspirational to the maker of pictures.

68) Page Left
'Seahorse'
Media: Pencil
Size: 370 mm * 260 mm

69) Page Right
'Action Over The Headland'
Media: Watercolour
Size: 340 mm * 540 mm

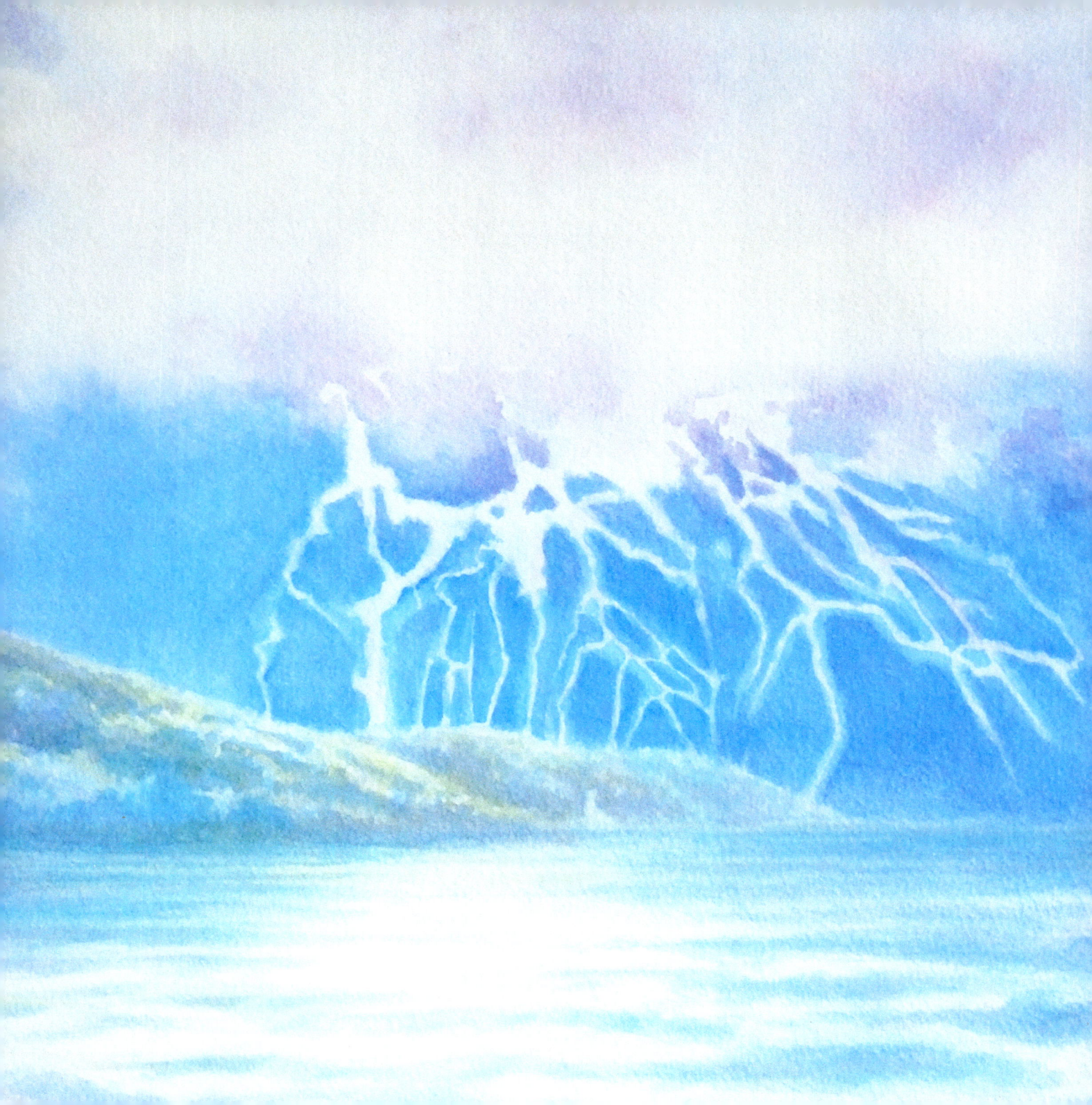

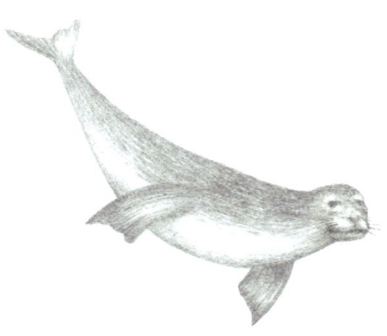

This collection of sketches and ramblings from my notebooks concludes with an image that depicts a sailboat beating against the wind in attempt to round Pendennis Point, such an image is a good metaphor for making pictures, and of course; many other things in life. Sometimes it's hard to push forward but sooner or later the wind will inevitably change to being in your favour. I hope that these words and pictures have brought to you something of value to yourself.

I wish for you that you be as happy as a seal full of fish.
Al Cazu.

70) Page Left / Top
'Loose Footed'
Media: Watercolour
Size: 340 mm * 540 mm

71) Page Left / Bottom
'Smiling Seal'
Media: Pencil
Size: 370 mm * 440 mm

Three Rivers & An Ocean

Cazu

Productions & Publishing

email: mail@alcazu.com

tel: 07745606275

To view a full catalogue of artwork
by Al Cazu:
www.cazu.co.uk

To purchase this book and other books by Al Cazu from
Amazon go to Al's Authors Page at:

https://www.amazon.co.uk/Al-Cazu/e/B00CIVSQKU

www.ingramcontent.com/pod-product-compliance
Lightning Source LLC
Chambersburg PA
CBHW041314180526
45172CB00004B/1094